DUCCIO TO LEONARDO

ITALIAN PAINTING 1250–1500

THE NATIONAL GALLERY

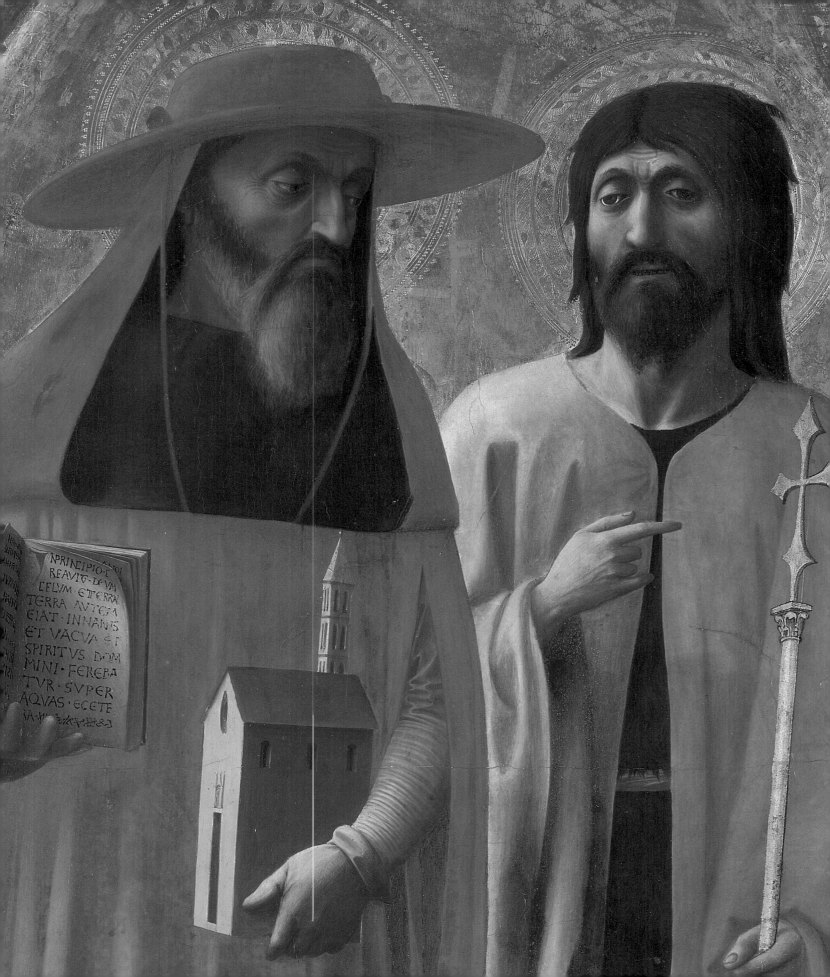

NPRINCIPIO·T
REAVIT·DVM
CELVM·ET·TERRA
TERRA·AVTEM
EIAT·INNANIS
ET·VACVA·ET
SPIRITVS·DOM
MINI·FEREBA
TVR·SVPER
AQVAS·ECETE

NATIONAL GALLERY COMPANY, LONDON
DISTRIBUTED BY YALE UNIVERSITY PRESS

DUCCIO TO LEONARDO

ITALIAN PAINTING 1250–1500

THE NATIONAL GALLERY

First published in Great Britain in 2009 by

National Gallery Company Limited

St Vincent House

30 Orange Street

London WC2H 7HH

www.nationalgallery.co.uk

ISBN 978 1 85709 421 3

525522

British Library Cataloguing-in-Publication Data

A catalogue record is available from the British Library

Library of Congress Control Number: 2008937289

Publisher Louise Rice

Project Editor Claire Young

Editor Lise Connellan

Production Jane Hyne and Penny Le Tissier

Designer Joe Ewart for Society

Colour reproduction by D L Interactive UK

Printed and bound in Hong Kong by Printing Express

All measurements give height before width

Front cover: LEONARDO da Vinci (1452–1519) *The Virgin and Child with Saint Anne and Saint John the Baptist,* about 1499–1500 (detail, plate 38)

Frontispiece: MASACCIO (1401–1428/9?) and MASOLINO (about 1383– after 1436) *Saints Jerome and John the Baptist,* about 1428–9 (detail, plate 9)

Page 6: Fra ANGELICO (active 1417; died 1455) *Christ Glorified in the Court of Heaven,* about 1423–4 (detail, plate 10)

CONTENTS

INTRODUCTION
Simona Di Nepi
7

THE PAINTINGS
12

CAPTIONS
Simona Di Nepi
52

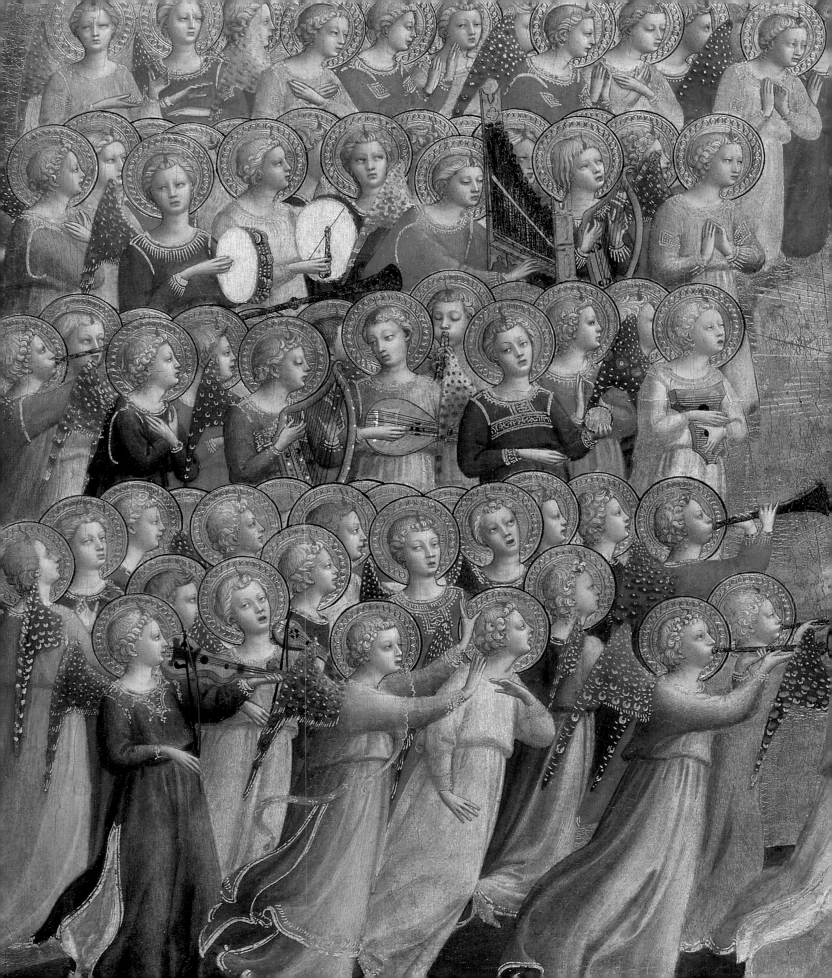

Introduction

Even a collection as rich and comprehensive as the National Gallery's, considered by many to be the most evenly balanced across all European schools, has areas of particular strength – and one of them is unquestionably the early Italian Renaissance. In the Sainsbury Wing, the set of galleries that from 1991 has housed the earliest part of the collection, hang masterpieces by some of the giants of Western European painting, such as Cimabue, Duccio, Giotto, Masaccio, Piero della Francesca, Sandro Botticelli, Andrea Mantegna and Giovanni Bellini. Others – such as Bernardo Daddi, Antonio and Piero del Pollaiuolo, Pietro Perugino and Antonello da Messina – may be less well known by the wider public but played a vital role in the history of Italian painting. Spanning more than two and a half centuries, from 1250 to about 1500, this part of the collection vividly traces the development of Italian painting from the almost exclusively religious art of the thirteenth and fourteenth centuries to the emergence of new, secular subjects in the fifteenth century. Thus portraits and mythological paintings make their first appearances among the sacred images of the Virgin and Child, Christ's Miracles and Passion, and the lives of saints. The broadening of subject matter reflects the gradual change in the function and destined setting of works of art, as wealthy patrons started to commission pictures not only to adorn high altars and family chapels, but also to embellish the sumptuous rooms of their private dwellings. Although the subjects of paintings evolved during this period, the context in which they were produced remained largely the same: masters and their collaborators worked in bustling workshops where young apprentices were given a range of tasks (such as grinding pigments or preparing wood panels for painting). That the visitor to the Sainsbury Wing should encounter so many fragments, rather than complete works, is partly the result of the troubled political and social situation in Italy during the late eighteenth and early nineteenth centuries. During this period, most notably under Napoleon Bonaparte (Emperor of the French Empire 1804–14/15), churches, convents and monasteries were suppressed; paintings were taken down from altars, disassembled and sold as separate pieces.

The paintings featured in this book, which include many of the most loved in the National Gallery, were not always considered worthy of attention. Indeed, the history of the formation of this part of the collection provides a fascinating insight into the change in attitude towards early Italian painting, from plain disdain to true passion. When the Gallery was founded, in 1824, very few in Britain showed interest in the so-called 'Primitives'. Even those who collected such works saw them as historic curiosities rather than objects of beauty. The highest praise was generally reserved for works by masters of the High Renaissance and the Baroque. Therefore it comes as no surprise that the three core groups of paintings that entered the National Gallery in its early years –

38 pictures purchased from John Julius Angerstein, 11 pictures donated by Sir George Beaumont and 31 paintings bequeathed by the Reverend William Holwell Carr – included works by Correggio, Titian, Jacopo Tintoretto, Paolo Veronese, Antonio and Annibale Carracci, Guido Reni and Domenichino (alongside Peter Paul Rubens, Rembrandt, Claude and Nicolas Poussin), but not a single Italian painting predating 1500.

By the middle of the nineteenth century taste in Britain was beginning to change: while many had come to accept the historic value of works previously dismissed as 'rude and barbarous', an influential group of discerning art lovers began to praise works by painters such as Fra Angelico and Perugino for their 'intrinsic beauty' and 'moving spirituality'. As a result, criticism of the Gallery's limited acquisition policy mounted: 'We are poor in fine specimens of some of the best of the early Italian masters', complained Mrs Anna Jameson in her 1842 *Handbook to the Public Galleries of Art in and near London*. A few years earlier pressure had come from official spheres, with the 1836 report by the government's Select Committee on Arts and their Connexion with Manufacturers exhorting the National Gallery to 'give an history of early art'. In spite of these recommendations, over the following 20 years the Trustees acquired only three early Italian pictures. Fortunately one of them was Giovanni Bellini's extraordinarily vivid portrait of Doge Leonardo Loredan, formerly in William Beckford's collection.

In March 1853 the government appointed a new Select Committee to inquire into the management of the National Gallery. Its report stressed that the Gallery should not 'merely exhibit to the public beautiful works of art, but instruct the people in the history of that art', adding that 'a just appreciation of Italian painting can as little be obtained from an exclusive study of the works of Raphael, Titian, or Correggio, as a critical knowledge of English poetry from the perusal of a few masterpieces. What Chaucer and Spenser are to Shakespeare and Milton, Giotto and Masaccio are to the great masters of the Florentine school.' In March 1855 the Treasury stated even more unequivocally that 'as a general rule preference should be given to good specimens of the Italian schools, including those of the earlier masters', and for this purpose appointed the first Director of the National Gallery. Painter, connoisseur and collector, Charles Lock Eastlake (1793–1865) was a man of rare knowledge and boundless energy. Before becoming Director, he had been Keeper and then a Trustee, while also serving as President of the Royal Academy (which at the time shared the same premises in Trafalgar Square). Driven by the belief that the National Gallery should serve as a complete and 'visible history of art', Eastlake did more to enhance the Gallery's holdings of early Italian paintings in the 10 years of his directorship than any other individual before or since. Through the help of his trusted travelling agent, Otto Mündler, his contact with eminent connoisseurs and, above all, his numerous trips to Italy, Eastlake undertook a systematic hunt for the most 'eligible' specimens of Italian art. His search resulted in an astonishing number of remarkable acquisitions, including Fra Angelico's *Christ Glorified in the Court of Heaven*, Fra Filippo Lippi's *Seven*

Saints, Piero della Francesca's *Baptism of Christ*, Giovanni Bellini's *Madonna of the Meadow*, Antonio and Piero del Pollaiuolo's *Martyrdom of Saint Sebastian*, and three panels from Perugino's altarpiece for the Certosa di Pavia (charterhouse). Eastlake also acquired numerous panels by Carlo Crivelli, a singular fifteenth-century artist about whom most contemporary critics were sceptical, if not harsh. When, in 1859, the Director bought his first Crivelli from a dealer in Rome, the Art Journal complained that *The Dead Christ supported by Two Angels* was an 'exceedingly hard and dry work' and 'a too faithful representation of the detail of post-mortem emaciation'. In spite of the prevailingly critical view of this 'extravagant' artist, Eastlake and his immediate successors acquired 13 paintings (some of which were gifts), creating the single richest collection of works by this painter. But perhaps the greatest achievement of Eastlake's directorship was the purchase in 1857 of 22 early Italian pictures from the Lombardi-Baldi collection in Florence, including Duccio's exquisite portable altarpiece depicting *The Virgin and Child with Saints Dominic and Aurea* and Paolo Uccello's *Battle of San Romano*. After a lengthy negotiation, Francesco Lombardi and Ugo Baldi abandoned their demand that the sale should comprise their entire collection of 100 paintings and accepted Mündler's offer. Contact with the Florentine collectors was nurtured, and five years later they sold to the Gallery the moving *Satyr mourning over a Nymph* by Piero di Cosimo. As a testament to Eastlake's devotion to the institution, many of his own fifteenth-century Italian paintings now hang in the National Gallery. In 1861 he donated Lippi's *Annunciation*, and after his death Lady Eastlake carried on her husband's legacy by presenting two pictures, by Pisanello and Giovanni Bellini. She later sold to the Gallery 15 pictures at the price Eastlake had originally paid.

Though the 'Eastlake era' was not to be repeated, the second half of the nineteenth century continued to be a successful time for acquisitions, despite the accelerating rise in prices and the tightening of export laws introduced by the newly formed Italian state after 1861. In 1866, on the appointment of William Burton as Director, the Gallery acquired *Portrait of a Lady* by Alesso Baldovinetti and *Tobias and the Angel*, now attributed to the workshop of Andrea del Verrocchio. Both paintings originally entered the Gallery with different attributions: the *Portrait of a Lady* was attributed to Piero della Francesca and the *Tobias and the Angel* to Antonio del Pollaiuolo. In 1874 Burton secured 13 more pictures at the posthumous sale of Alexander Barker, the son of a boot-maker who had amassed a renowned collection of Tuscan, Umbrian and Venetian fifteenth-century works. Writing a few days before the sale, Benjamin Disraeli, then First Lord of the Treasury, stated: 'If the Barker pictures are so rare and wondrous as I hear, it shall go hard if the nation does not possess them.' In addition to three further panels by Crivelli, the group included Piero's *Nativity* and Botticelli's *Venus and Mars*. This last acquisition was complemented four years later by the purchase of another famous Botticelli, the '*Mystic Nativity*', which had been part of the distinguished Aldobrandini collection in Rome before belonging to the artist and connoisseur William Young Ottley (1771–1836).

While the Trustees and Keeper of the National Gallery had managed to secure fine examples of the Florentine, Umbrian, Venetian and Ferrarese schools, they had entirely neglected the work of Sienese artists. This lack of interest was not exclusive to the National Gallery, but rather the result of a well-established historiographic tradition, which, influenced by the vision of Giorgio Vasari's *Lives of the Most Eminent Painters, Sculptors and Architects* (first published in 1550 and then in a massively revised edition in 1568), consistently ranked Florentine painters above masters such as Duccio, Pietro and Ambrogio Lorenzetti, and Simone Martini. In the 1880s and 1890s this was to change thanks to the activities of the painter, collector and dealer Charles Fairfax Murray (1849–1919). Driven by an almost missionary zeal to give Sienese art its due, Murray acted as agent and adviser to Burton, as well as for other museums in Britain and abroad. In the early 1880s he sold the Gallery five pictures, including Matteo di Giovanni's majestic *Assumption of the Virgin*, the shimmering *Marriage of the Virgin* by Niccolò di Buonaccorso and, most notably, *Jesus opens the Eyes of a Man born Blind* and *The Annunciation* from Duccio's monumental double-sided *Maestà* for Siena Cathedral. As on other occasions in the National Gallery's past, the purchase of fragments encouraged generous individuals to donate other elements from the same dismantled whole, and in 1891 R. H. Wilson presented the Gallery with *The Transfiguration*, a third panel from the back of the *Maestà*.

By 1900 the National Gallery could boast an impressive collection of early Italian paintings, with particularly strong holdings of works by Botticelli, Mantegna, Giovanni Bellini and Crivelli. Perhaps because the Director was now rarely travelling in search of works and the Italian authorities had tightened up export controls, in the next century the early Italian schools were enhanced primarily by gifts and bequests rather than purchases. The most generous donation came in 1909 from Ludwig Mond, a wealthy industrialist of German origin, who bequeathed the National Gallery 56 paintings, including a number of important fifteenth-century works. It was only under Kenneth Clark, appointed Director in 1934, that the Gallery resumed its active acquisition of early Italian works. Clark's association with the distinguished American scholar Bernard Berenson was to have a decisive influence on his taste, and in the 1940s his interest in art of fifteenth-century Siena was reflected in the purchase of two important works: the seven panels from Sassetta's *Life of Saint Francis* and four panels with *Scenes from the Life of Saint John the Baptist* by Giovanni di Paolo. Both acquisitions were made possible by the support of the National Art Collections Fund (NACF), an independent charity founded in 1903 to save works of art from export for the benefit of public collections. Since its creation the NACF (now The Art Fund) has played a major role in enhancing the National Gallery Collection, securing numerous acquisitions both through organising fund-raising campaigns and with its own contributions. Among the masterpieces that were acquired via the NACF are Masaccio's *Virgin and Child* – the central panel of the artist's only documented work – purchased by the Gallery in 1916, and Leonardo da Vinci's *Virgin and Child with Saint Anne and Saint John the Baptist* (also known as the *Leonardo Cartoon*) in 1962. When, on 11 March

1962, Philip Hendy, the Gallery's then Director, read in a newspaper that the Royal Academy intended to sell Leonardo's monumental drawing at auction, the entire country was mobilised to raise funds for the National Gallery to acquire it. The British Museum's Department of Prints and Drawings, the most obvious candidate for the acquisition, was ruled out due to the lack of a satisfactory space to display the Cartoon. While the campaign for funds was launched at schools, libraries and art galleries, the National Gallery swiftly put the Cartoon on view in its largest room. The public flocked to see it, leaving donations in the collection boxes and returning home with an infectious enthusiasm for the cause. The public appeal was enthusiastically endorsed by the press, and *The Times* shouted patriotically: 'If Leonardo goes abroad it will not be for lack of money but for lack of spirit!' In a mere four months the asking price of £800,000 – the highest hitherto paid by the National Gallery – was met.

The need for such collective efforts, which have thankfully been repeated since the triumphal story of the Leonardo Cartoon, signals the fact that profound changes have taken place in the art market since the early days of the National Gallery. Indeed, together with the growth in appreciation for early Italian paintings has come the incalculable rise in their market value, and paintings once disparagingly called 'primitive' are now unattainable. If acquiring paintings in the open market has become increasingly difficult for museums, it is through the help of various art funds and charities – both public and private, as well as government schemes – that the National Gallery can still hope to secure master-pieces. In 2000, for instance, the government allocated Cimabue's *Virgin and Child enthroned with Two Angels* to the National Gallery in lieu of inheritance tax. This tiny panel, the only work by Cimabue in Great Britain and a veritable gem of thirteenth-century art, was found hanging inconspicuously on the wall of a country house in Suffolk. There is no doubt that it has filled a formidable gap in the Gallery's presentation of Western painting. In addition, in 2004 a generous grant from the American Friends of the National Gallery enabled the acquisition of Bernardo Daddi's splendid *Coronation of the Virgin*. These recent additions are encouraging signs that the National Gallery's holdings of early Italian paintings, an already extraordinarily fine and varied collection, can continue to grow and expand.

Simona Di Nepi

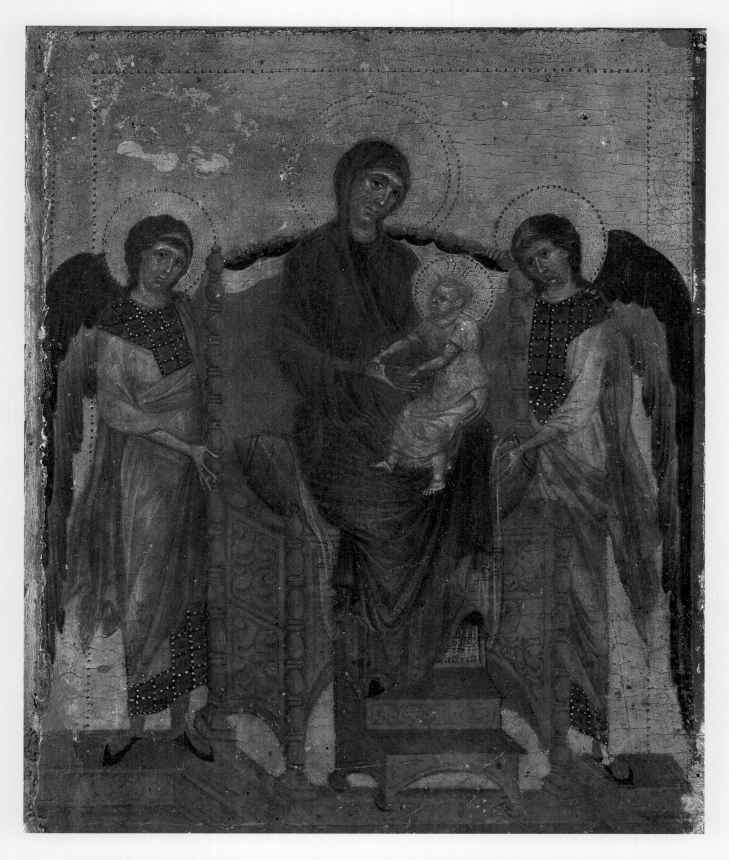

1 CIMABUE (about 1240–1302) *The Virgin and Child Enthroned with Two Angels*, about 1265–80

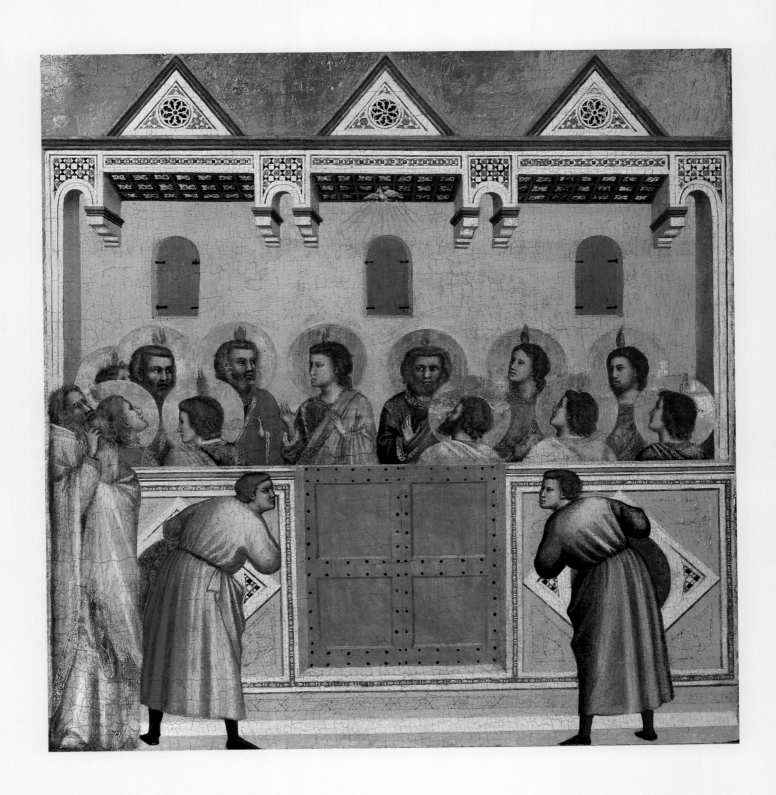

2 GIOTTO di Bondone (1266/7; died 1337) *Pentecost*, about 1312–15

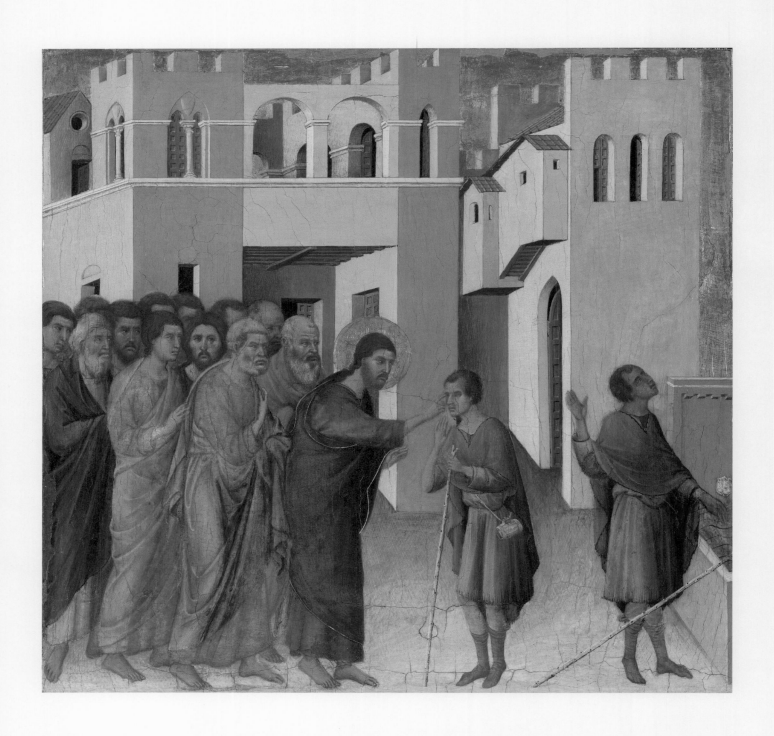

3 DUCCIO di Buoninsegna (active 1278; died 1318/19) *Jesus opens the Eyes of a Man born Blind*, 1311

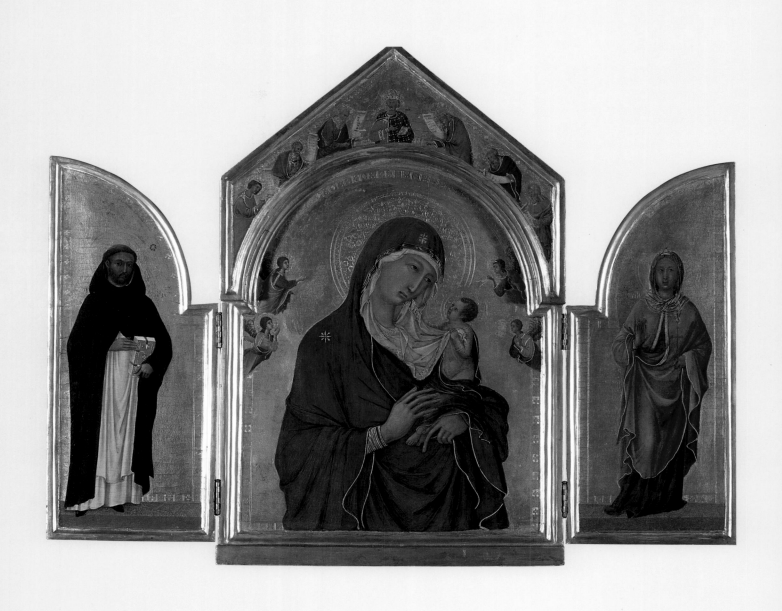

4 DUCCIO di Buoninsegna (active 1278; died 1318/19) *The Virgin and Child with Saints Dominic and Aurea,*
about 1315

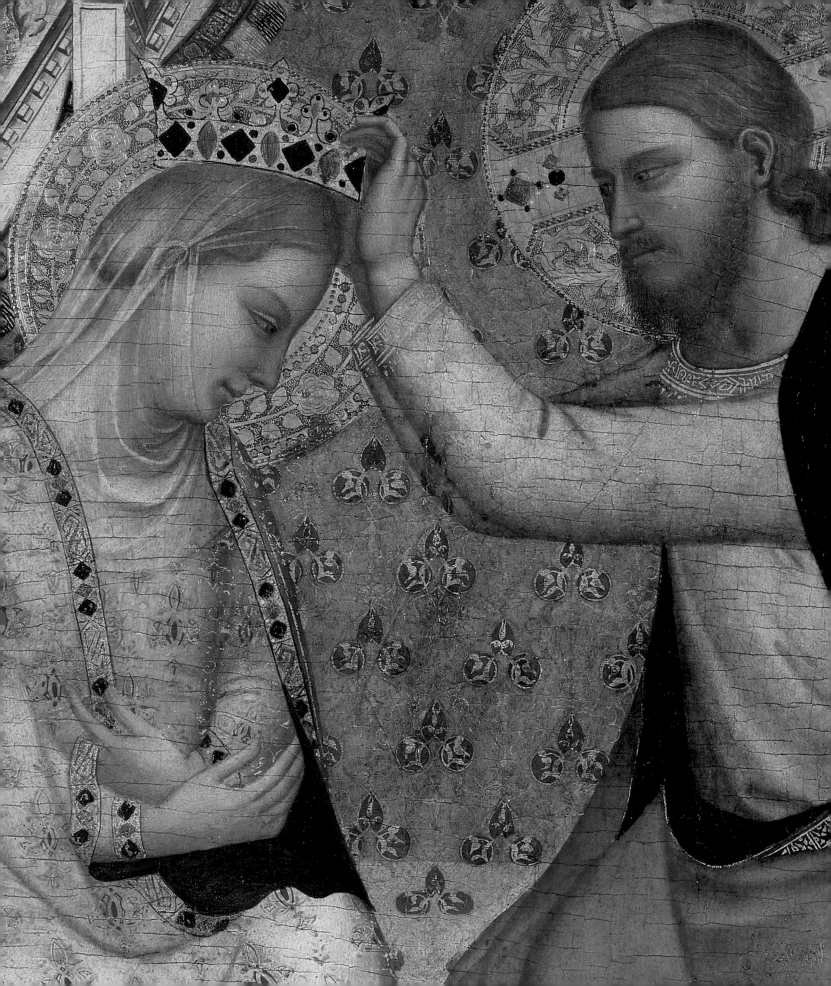

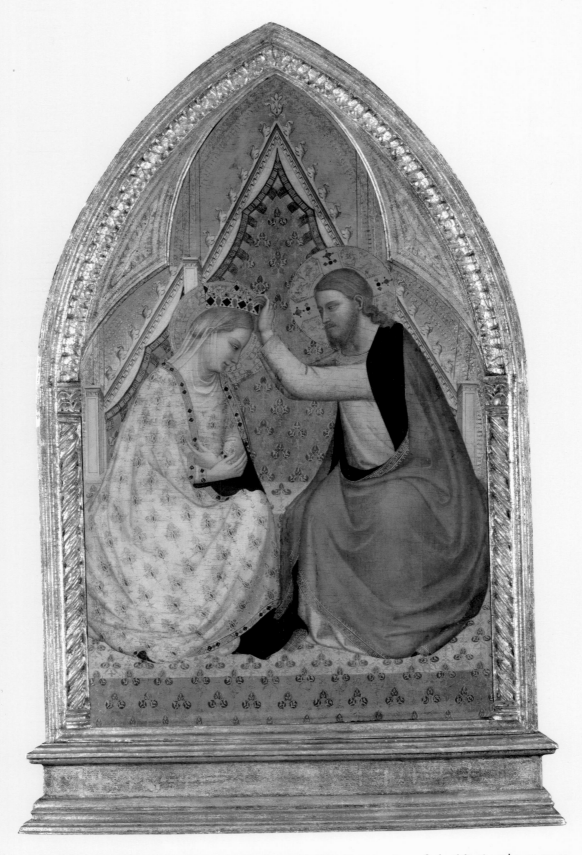

5 Bernardo DADDI (active by 1320; died 1348) *The Coronation of the Virgin,* about 1340

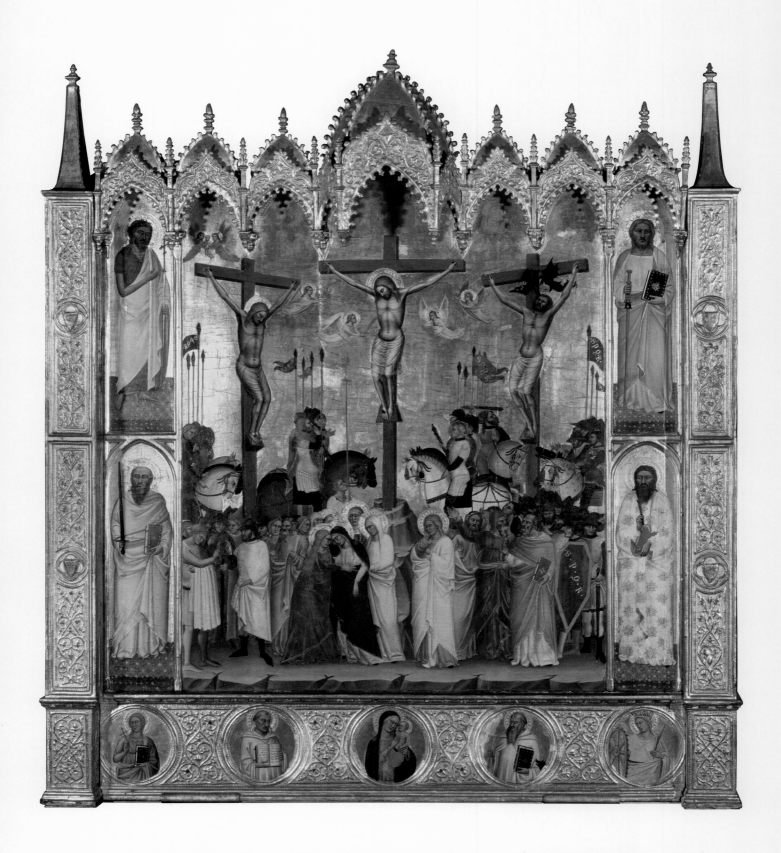

6 Attributed to Jacopo di CIONE (died 1398/1400) *The Crucifixion*, about 1368–70

18

7 NICCOLÒ di Buonaccorso (active about 1370, died 1388) *The Marriage of the Virgin*, about 1380

8 MASACCIO (1401–1428/9?) *The Virgin and Child*, 1426

9 MASACCIO (1401–1428/9?) and MASOLINO (about 1383–after 1436) *Saints Jerome and John the Baptist,*
about 1428–9

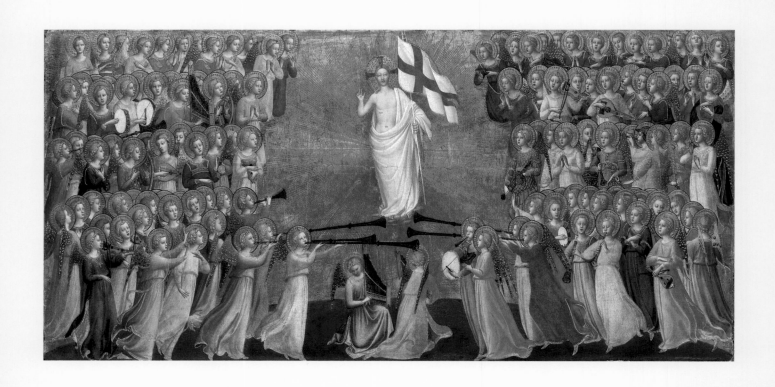

10 Fra ANGELICO (active 1417, died 1455) *Christ Glorified in the Court of Heaven*, about 1423–4

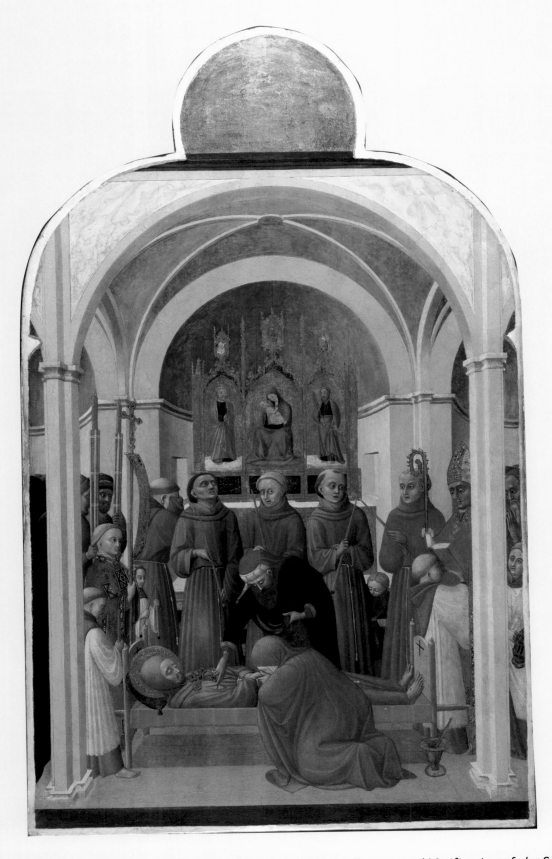

11 SASSETTA (active by 1427, died 1450) *The Funeral of Saint Francis and Verification of the Stigmata,*
1437–44

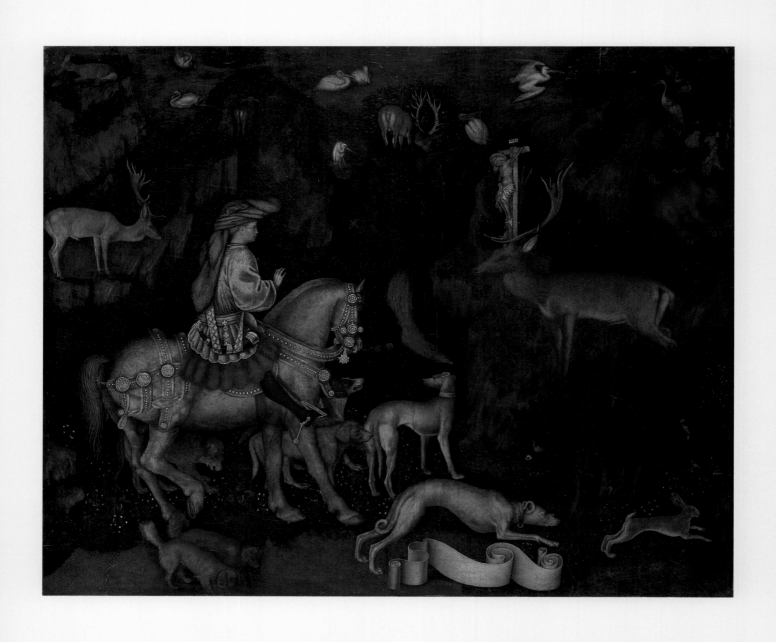

12 PISANELLO (about 1394?– 1455) *The Vision of Saint Eustace,* about 1438–42

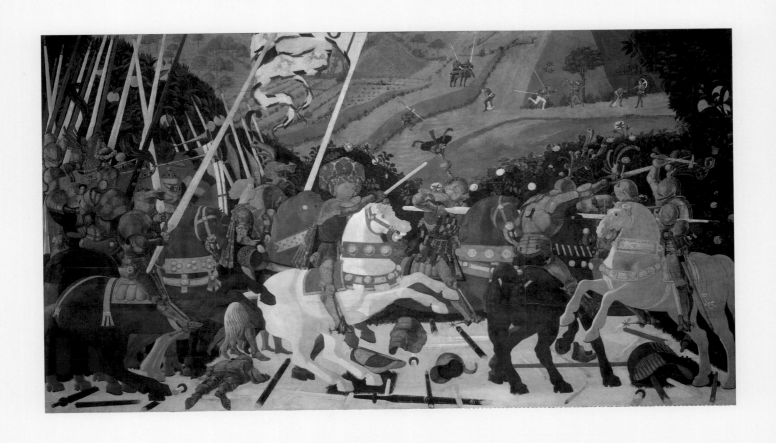

13 Paolo UCCELLO (about 1397–1475) *The Battle of San Romano*, probably about 1438–40

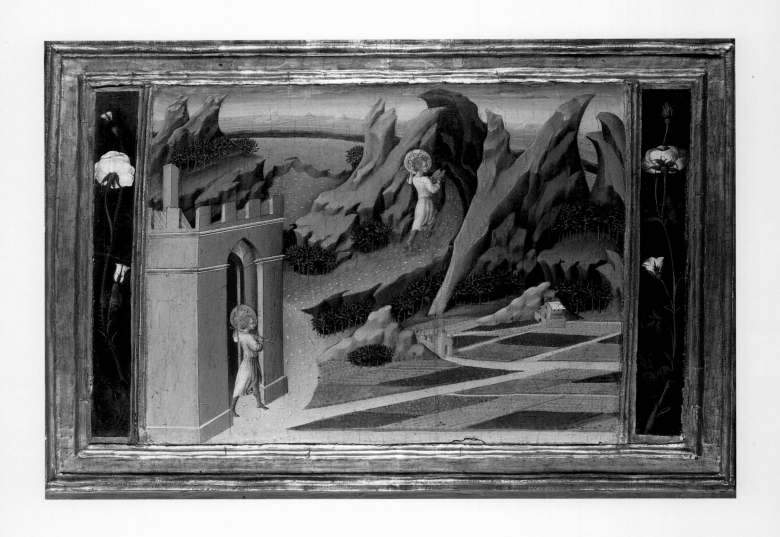

14 GIOVANNI di Paolo (active by 1417, died 1482) *Saint John the Baptist retiring to the Desert*, 1454

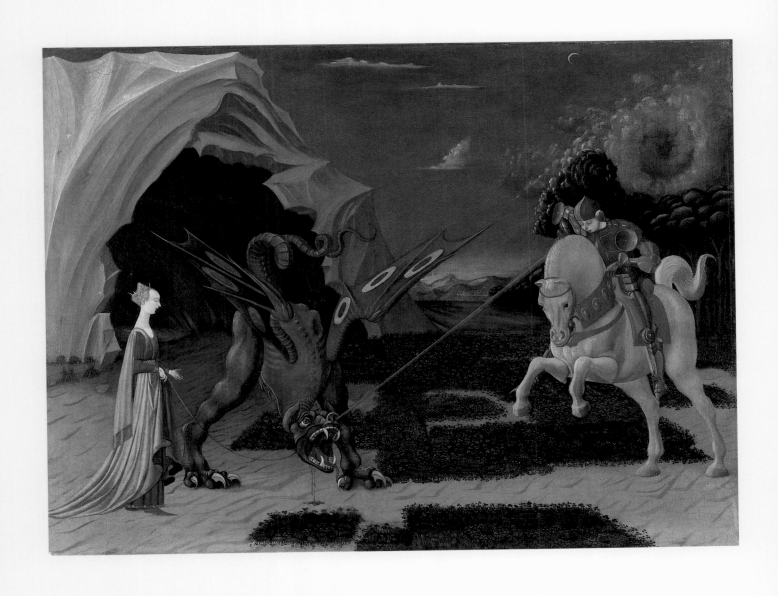

15 Paolo UCCELLO (about 1397–1475) *Saint George and the Dragon*, about 1470

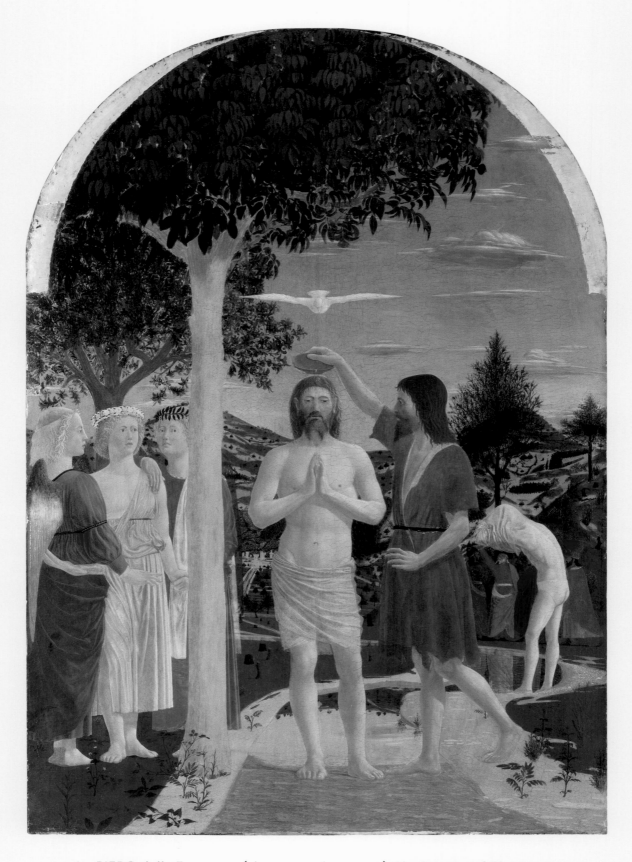

16 PIERO della Francesca (about 1415/20 – 1492) *The Baptism of Christ*, 1450s

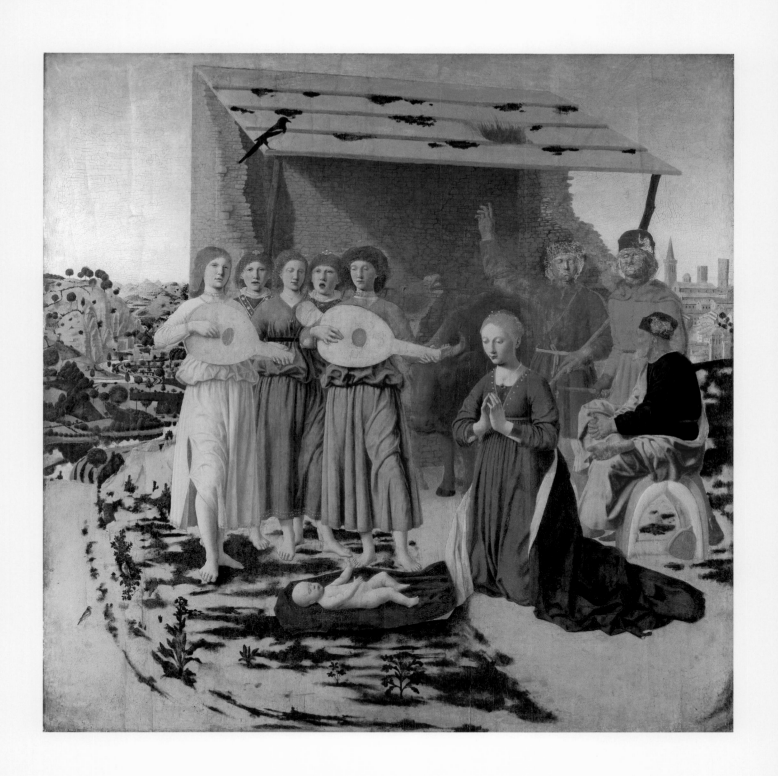

17 PIERO della Francesca (about 1415/20 – 1492) *The Nativity*, 1470 – 5

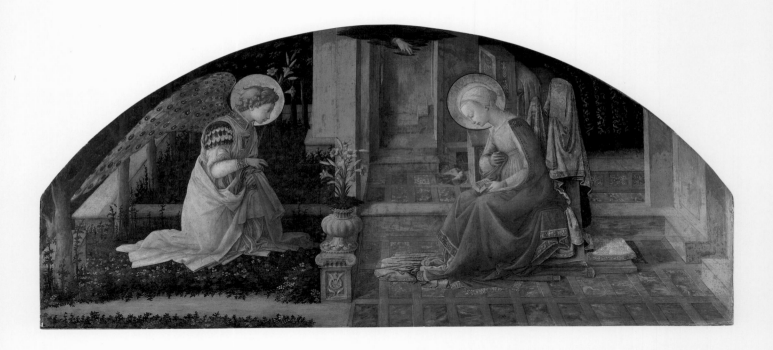

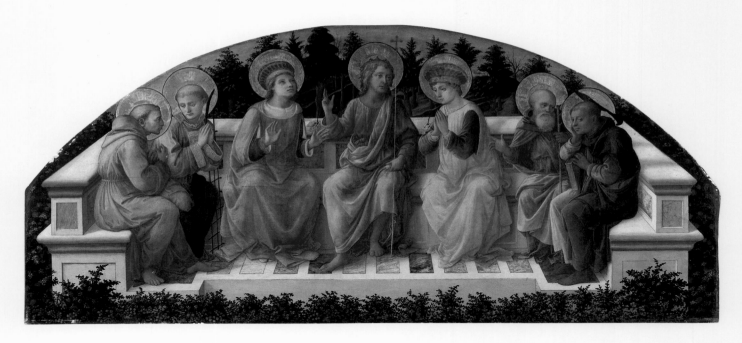

18 Fra Filippo LIPPI (born about 1406, died 1469) *The Annunciation*, about 1450–3

19 Fra Filippo LIPPI (born about 1406, died 1469) *Seven Saints*, about 1450–3

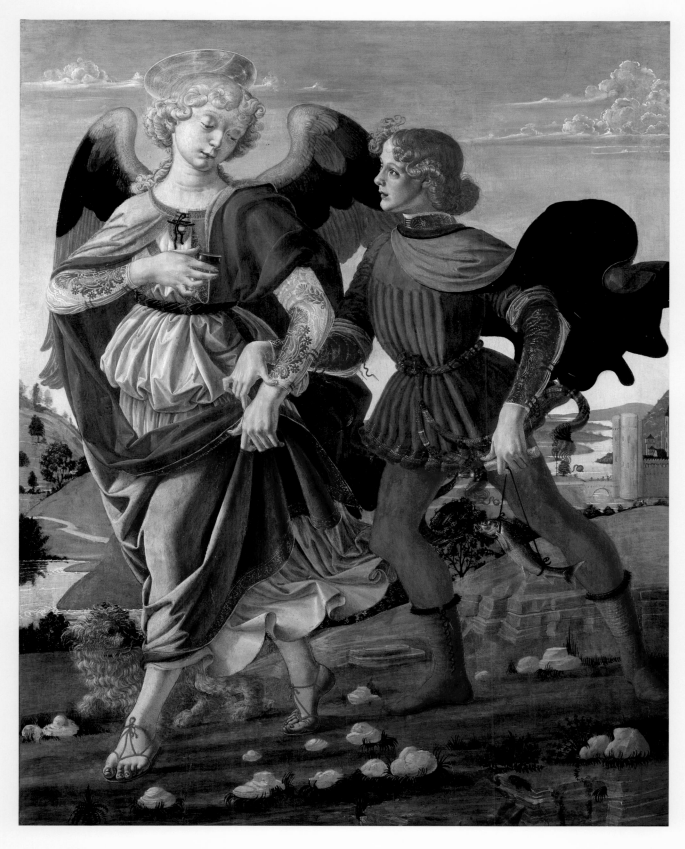

20 Workshop of Andrea del VERROCCHIO (about 1435–1488) *Tobias and the Angel*, 1470–80

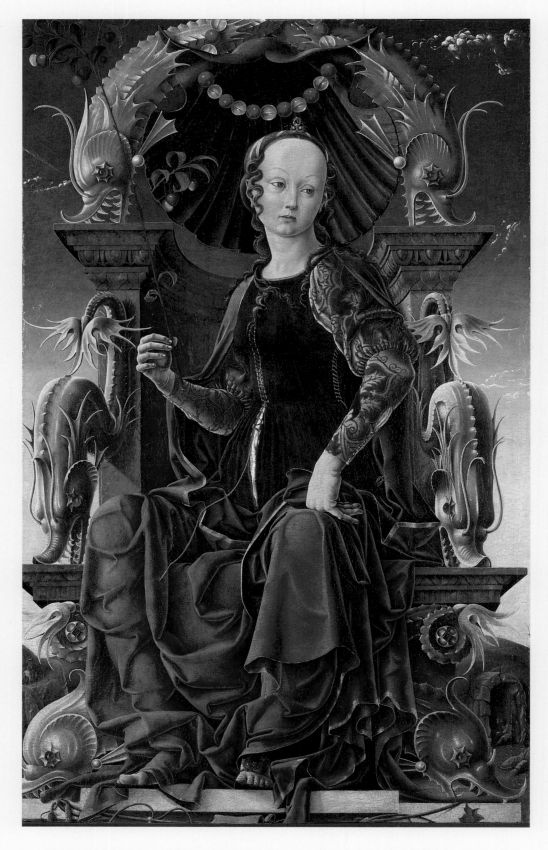

21　Cosimo TURA (before 1431–1495) *A Muse (Calliope?)*, probably 1455–60

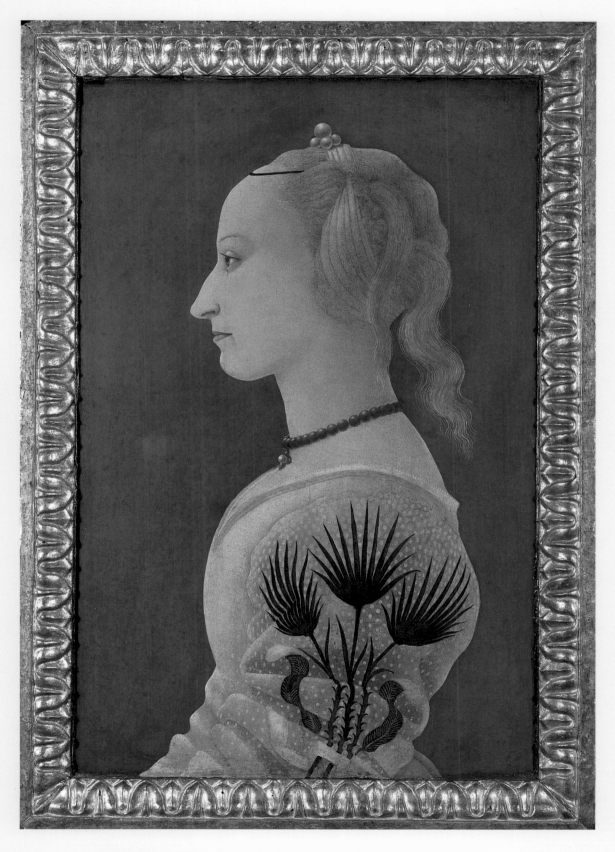

22　Alesso BALDOVINETTI (about 1426–1499) *Portrait of a Lady*, about 1465

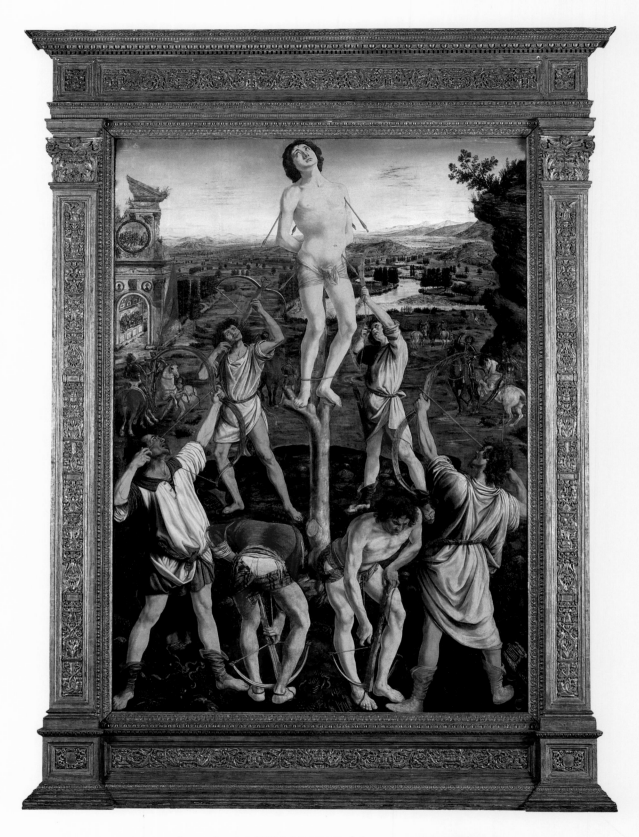

23 Antonio del POLLAIUOLO (about 1432 – 1498) and
Piero del POLLAIUOLO (about 1441 – before 1496)
The Martyrdom of Saint Sebastian, completed 1475

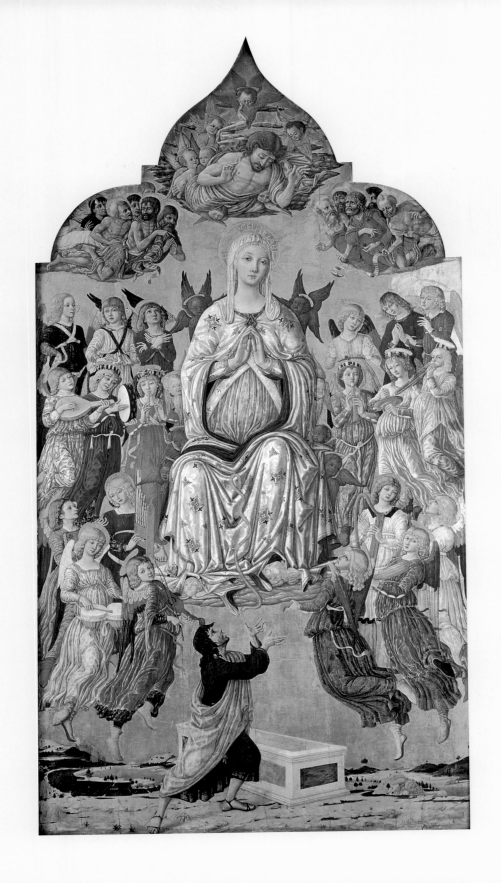

24　MATTEO di Giovanni (active by 1452, died 1495) *The Assumption of the Virgin*, probably 1474

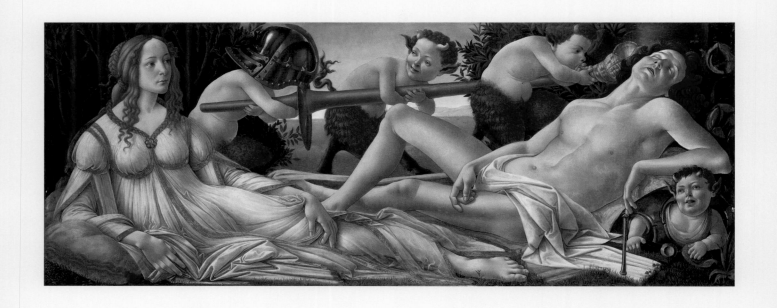

25　Sandro BOTTICELLI (about 1445–1510) *Venus and Mars*, about 1485

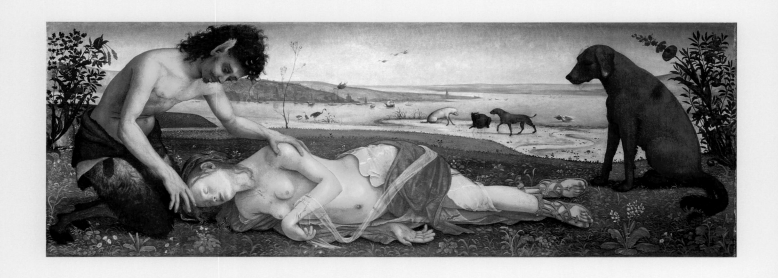

26 PIERO di Cosimo (1462–1522) *A Satyr mourning over a Nymph*, about 1495

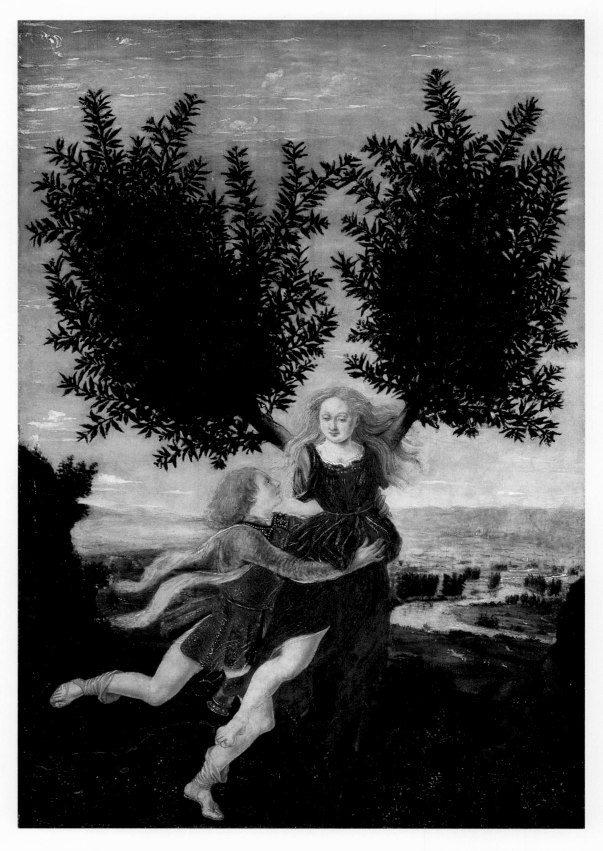

27 Antonio del POLLAIUOLO (about 1432–1498) *Apollo and Daphne,* probably 1470–80

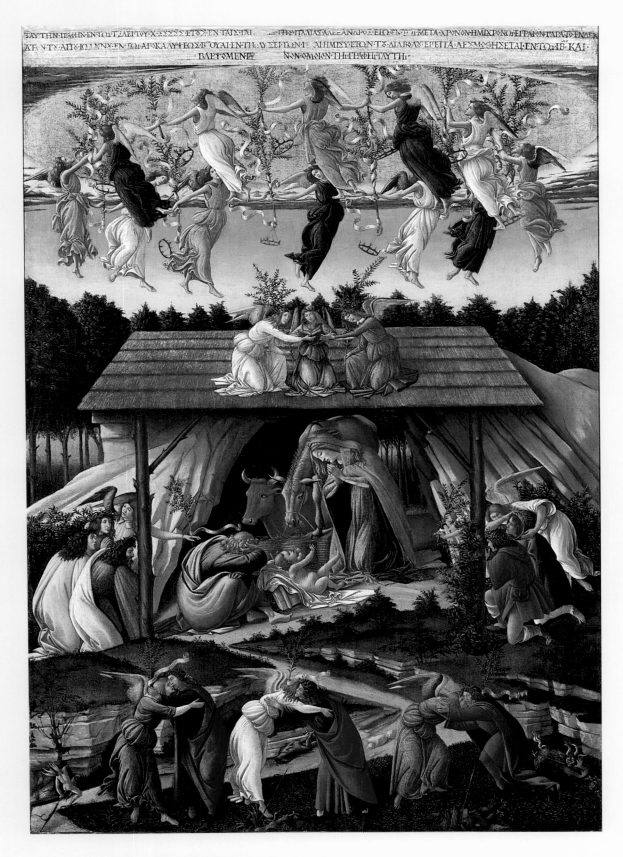

28 Sandro BOTTICELLI (about 1445–1510) *'Mystic Nativity'*, 1500

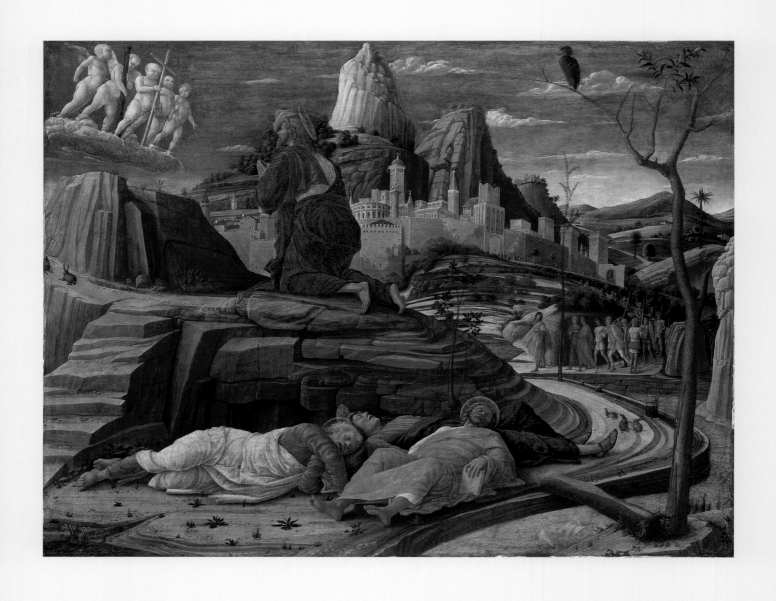

29 Andrea MANTEGNA (about 1430/1 – 1506) *The Agony in the Garden*, about 1460

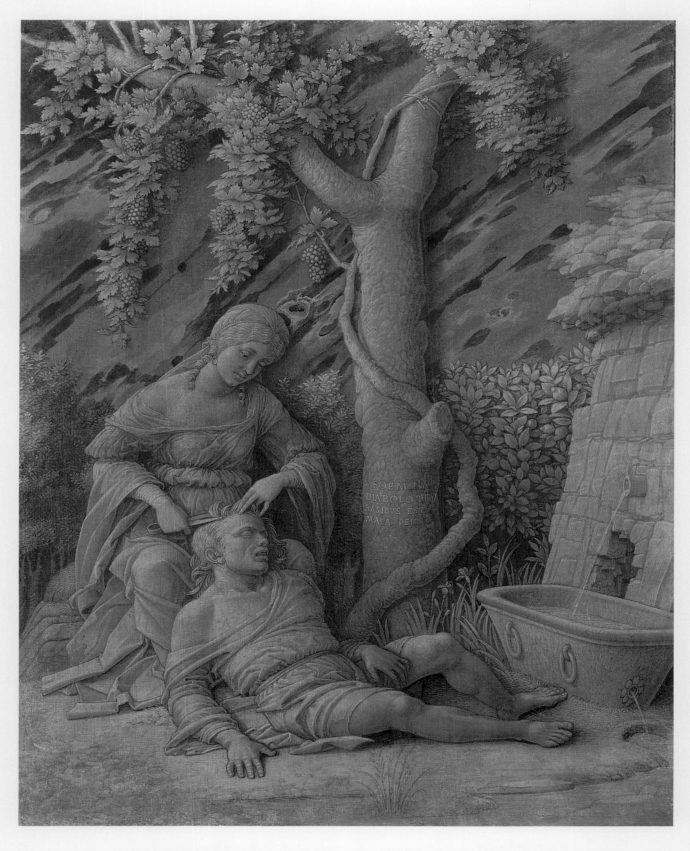

30 Andrea MANTEGNA (about 1430/1 – 1506) *Samson and Delilah*, about 1500

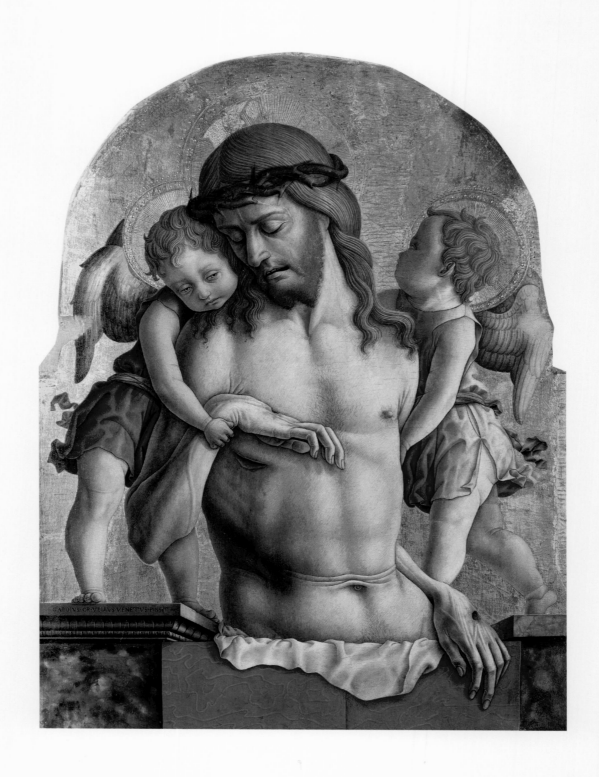

31 Carlo CRIVELLI (about 1430/5 – about 1494) *The Dead Christ supported by Two Angels,* about 1470–5

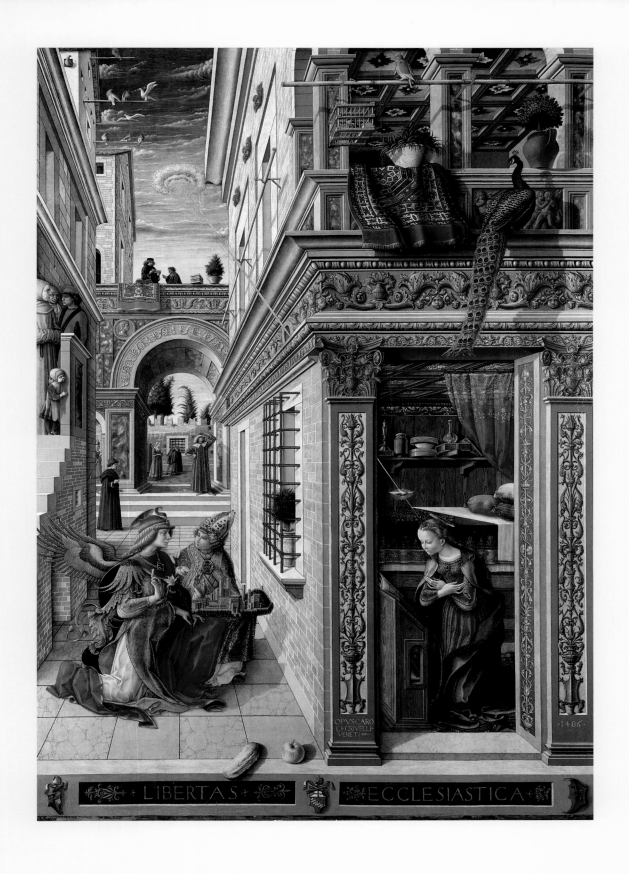

32　Carlo CRIVELLI (about 1430/5 – about 1494) *The Annunciation, with Saint Emidius*, 1486

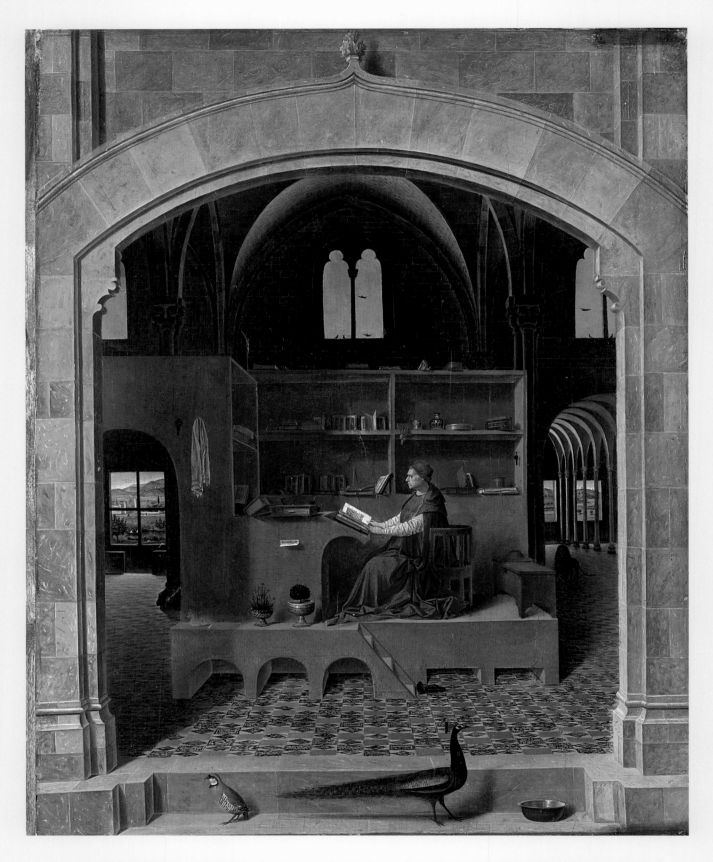

33 ANTONELLO da Messina (active 1456, died 1479) *Saint Jerome in his Study*, about 1475

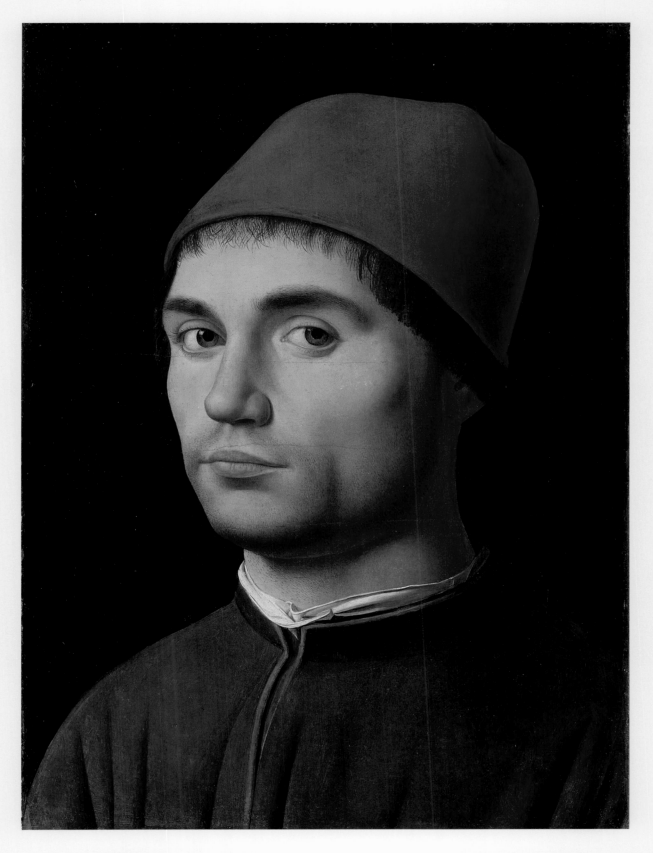

34 ANTONELLO da Messina (active 1456, died 1479) *Portrait of a Man*, about 1475–6

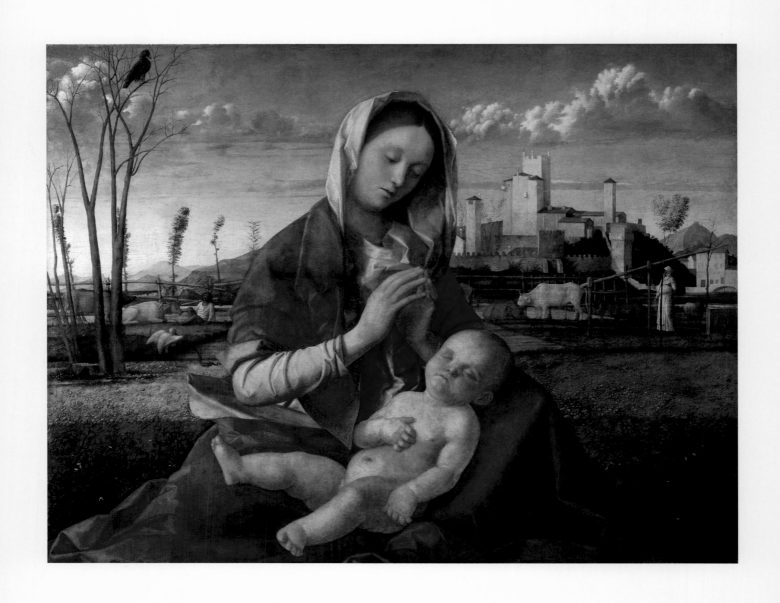

35 Giovanni BELLINI (active about 1459, died 1516) *Madonna of the Meadow*, about 1500

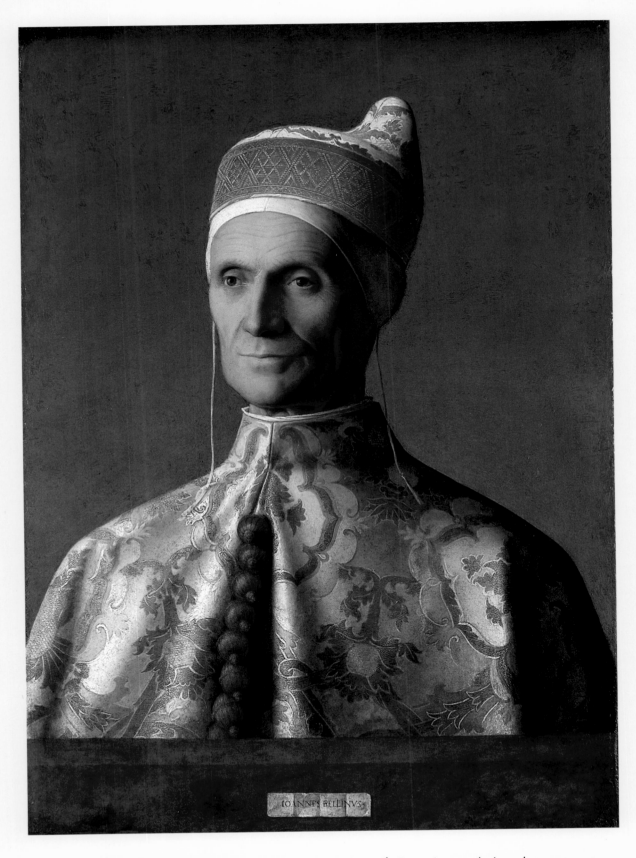

36 Giovanni BELLINI (active about 1459, died 1516) *Doge Leonardo Loredan, 1501 – 2*

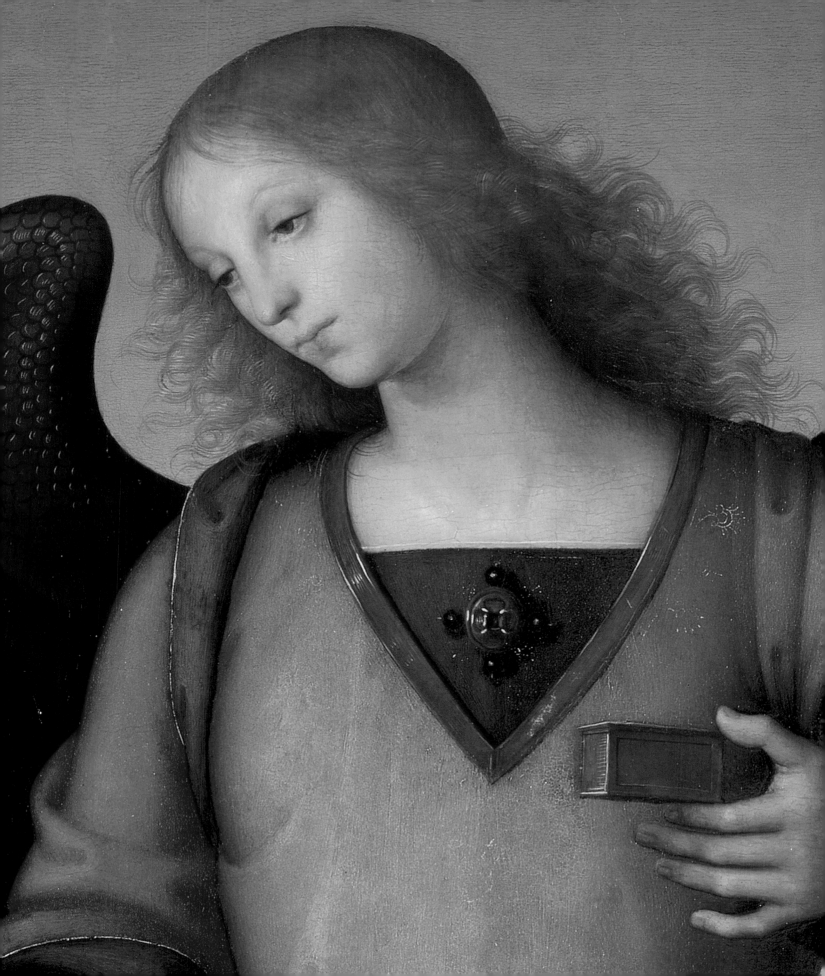

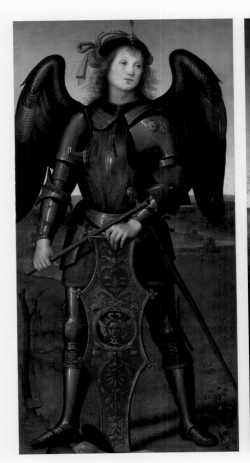 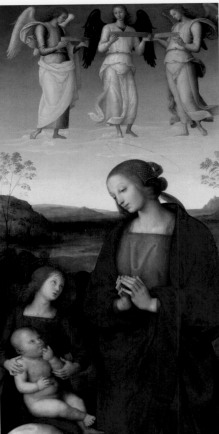 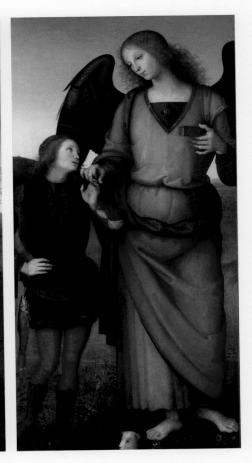

37 Pietro PERUGINO (alive in 1469–1523) *The Virgin and Child with an Angel, the Archangel Michael,*
and the Archangel Raphael with Tobias, about 1496–1500

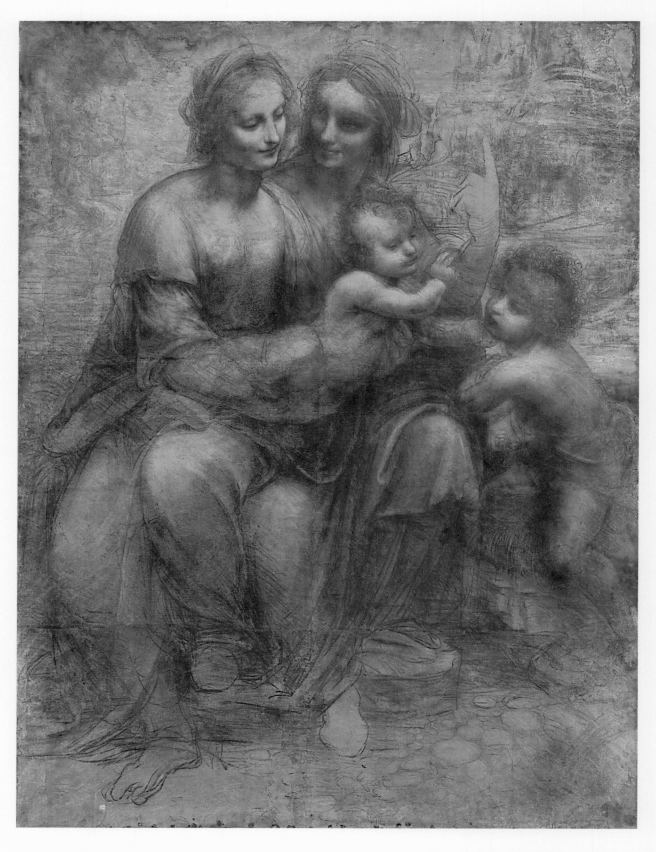

38 LEONARDO da Vinci (1452–1519) *The Virgin and Child with Saint Anne and Saint John the Baptist,*
about 1499–1500

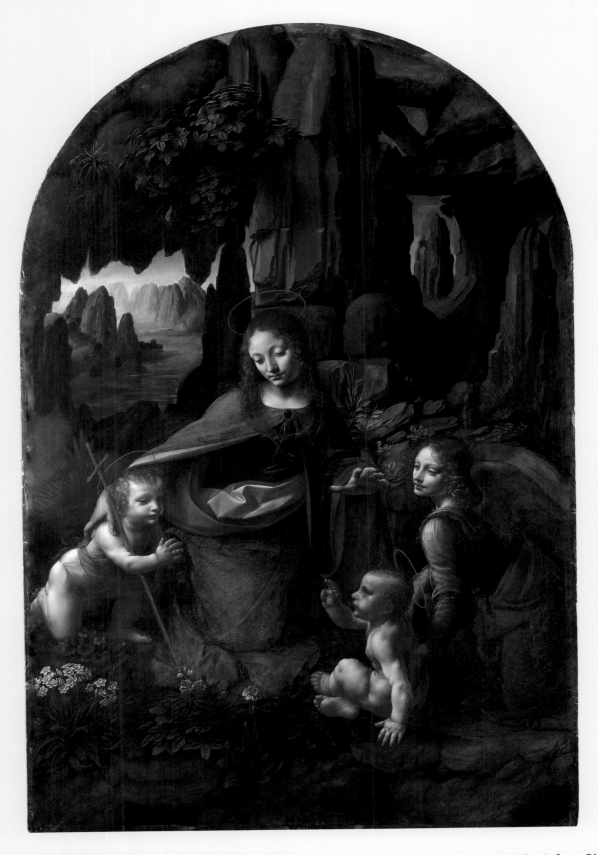

39 LEONARDO da Vinci (1452–1519) *The Virgin with the Infant Saint John adoring the Infant Christ accompanied by an Angel*, about 1491–1508

1 CIMABUE (about 1240–1302)
The Virgin and Child Enthroned with Two Angels, about 1265–80
Tempera on wood, 27.5 x 20.5 cm
Accepted by H.M. Government in lieu of Inheritance Tax and allocated to
the National Gallery, 2000

The subject of the first biography in Giorgio Vasari's famous *Lives of the Artists,*
Cimabue is considered to be the patriarch of Italian painting. Here the artist blends
the iconographic and formal motifs of Byzantine art with a new naturalism. He
creates a sense of spatial depth by positioning the throne and figures at an angle,
and outlining the floor with receding diagonals; he models the draperies with soft
shading, and paints the angels' wings with fluid strokes. The slight tilt of the Virgin's
head and playful gesture of the infant Christ are an early attempt at portraying the
intimate bond between mother and child in Italian painting.

When this tiny picture was discovered in an English country house it was realised
that it was once part of the same work as a little panel, *The Flagellation of Christ*
(Frick Collection, New York). The two panels are fragments of a lost work probably
depicting scenes from the life of Christ or the Virgin.

2 GIOTTO di Bondone (1266/7–1337)
Pentecost, about 1312–15
Tempera on wood, 45.5 x 44 cm
Bequeathed by Geraldine Emily Coningham in memory of Mrs Coningham of
Brighton and of her husband, Major Henry Coningham, 1942

This is a fragment from an altarpiece, which consisted of a long horizontal plank,
depicting seven scenes, including the Nativity and the Crucifixion. The *Pentecost*
completed the narrative cycle by showing the moment when, after Christ's
Resurrection, tongues of heavenly fire descended upon the twelve apostles. They
were filled with the Holy Spirit – shown here as a white dove – and amazed
witnesses from many nations by speaking in their own languages (Acts 2: 1–13).

Even during his lifetime Giotto was recognised as having changed the course of
painting. In his *Divine Comedy* Dante famously declared that the painter even
surpassed the older Cimabue. One of Giotto's major innovations was endowing his
figures with a sense of solidity. This can be seen in the two bulky foreground
figures, who were probably executed by Giotto himself. Other parts of the panel
would have been painted by studio assistants.

3 DUCCIO di Buoninsegna (active 1278, died 1318/19)
Jesus opens the Eyes of a Man born Blind, 1311
Tempera on poplar, 43.5 × 45 cm
Bought, 1883

This small panel comes from Duccio's *Maestà*, a monumental double-sided altarpiece painted for the high altar of Siena Cathedral. When completed in 1311 the *Maestà* was the largest and most costly panel painting ever produced. On the front was the enthroned Virgin and Child surrounded by saints and angels, with episodes from the Infancy of Christ below and the last days of the Virgin's life and her death above. The reverse panel was divided into more than 30 scenes depicting the Ministry and Passion of Christ. Although the altarpiece was dismembered in the eighteenth century, most of it still survives in the Siena Cathedral Museum.

This scene, part of the reverse predella, depicts one of Christ's miracles as told in Saint John's Gospel (9: 1-7). In the centre Christ smears the eyes of a blind man with spittle and mud, while on the right the same man is shown with his sight restored when he washes his eyes in the pool of Siloam. Since Duccio was not a particularly meticulous architecture painter, the complexity and precision of the buildings suggest they are probably by a specially trained assistant in his workshop.

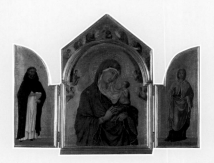

4 DUCCIO di Buoninsegna (active 1278, died 1318/19)
The Virgin and Child with Saints Dominic and Aurea, about 1315
Tempera on wood, 42.5 × 34.5 cm (main panel), 42 × 16.5 cm (shutters)
Bought, 1857

Duccio di Buoninsegna was highly influential in fourteenth-century Siena. In addition to producing monumental altarpieces with the aid of his large workshop, he also painted small devotional works such as this. This beautifully preserved triptych was made as a portable altarpiece for private prayer. In the central panel a delicately featured Virgin exchanges tender looks and sweet gestures with the Christ Child. Her brilliant blue robe, painted with precious ultramarine pigment, stands out against the tooled gold ground. On the shutters, saints Dominic and Aurea provide possible clues as to the identity of the patron: he may have been Niccolò da Prato (d. 1321), the Dominican cardinal who was bishop of Ostia, site of Saints Aurea's martyrdom. In the top gable, Old Testament prophets hold scrolls with inscriptions alluding to the Virgin.

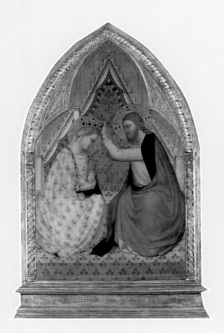

5 Bernardo DADDI (active by 1320, died 1348)
 The Coronation of the Virgin, about 1340
 Tempera on wood, 117.2 x 65.2 cm
 Bought with a grant from the American Friends of the National Gallery,
 London, made possible by Sir Paul Getty's endowment, 2004

Seated on a highly ornamented throne covered in an elegant silk textile, Christ crowns his mother as the Queen of Heaven. The Virgin, a delicate smile just perceptible on her lips, crosses her arms in a gesture of humility. This subject, one of the most common in fourteenth-century Florence, may refer to a nuptial image in the Old Testament (Psalm 45).

This fragment is the upper part of a painting of which the lower section shows four music-making angels, together with Saint John the Baptist and a deacon saint (probably Saint Stephen). The painting was cut into two panels at some time before 1828, when *The Four Musical Angels* was given as a separate picture to Christ Church, Oxford. The left edge, the top of the arch, and the step of the throne in *The Coronation of the Virgin* are all modern replacements. It is unclear if *The Coronation* was originally made as a single independent panel or as the centrepiece of a polyptych, with side panels featuring rows of saints.

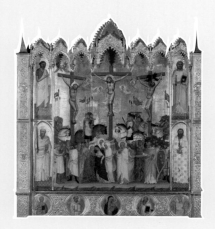

6 Attributed to Jacopo di CIONE (probably active 1362, died 1398/1400)
 The Crucifixion, about 1368–70
 Tempera on wood, 154 x 138.5 cm
 Bequeathed by the Reverend Jarvis Holland Ash, 1896

Together with his older brothers Andrea and Nardo, Jacopo di Cione dominated Florentine painting in the second half of the fourteenth century. He produced richly decorated paintings, intended to move the faithful through their refined beauty rather than accurate depiction of the real world. This small altarpiece, possibly the work of two painters, is no exception. The scene is painted in the most brilliant of tones and is enclosed within an elaborate gilded canopy, the original frame. At the top left two angels carry the soul of the good thief to heaven, while on the right the bad thief is being tortured by demons with burning coals, and by a soldier who is breaking his legs. On recognising the son of God, one soldier covers his mouth in disbelief, while another offers the Redeemer a vinegar-soaked sponge. The four full-length saints in the frame are, from top left, John the Baptist, Paul, James and Bartholomew. In the roundels below are the Virgin and Child flanked by a female saint, Saint Bernard, Saint Anthony Abbot and Saint Catherine of Alexandria.

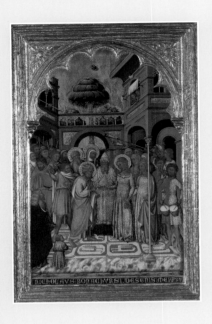

7 NICCOLÒ di Buonaccorso (active about 1370, died 1388)
The Marriage of the Virgin, about 1380
Tempera on wood, 51 × 33 cm
Bought, 1881

According to apocryphal texts, the Virgin's suitors were required to present rods at the Temple: she would then marry the man whose rod flowered. Joseph is shown placing a ring on the Virgin's finger while holding his rod, which has miraculously blossomed into the dove of the Holy Spirit. On the left the unsuccessful suitors watch in disappointment. One of them is held back by Saint Joachim, the Virgin's father, who stands beside Saint Anne, the Virgin's mother.

The scene is enlivened by details such as the chubby toddler in the foreground and the curious women gazing out of their window. The miniature-like size, vibrant colours and rich decorative effects are reminiscent of illuminated manuscripts. This panel is thought to have been at the centre of a triptych with the *Presentation of the Virgin* on the left, and the *Coronation of the Virgin* on the right (now, respectively, at the Uffizi, Florence and the Metropolitan Museum of Art, New York). The painter has inscribed along the bottom: *nicholavs: bonachvrsi: de senis: me pinxit* (Niccolò di Buonaccorso of Siena painted me).

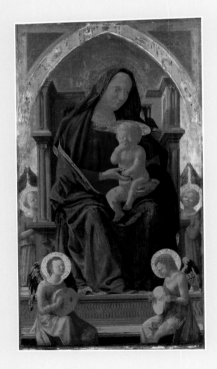

8 MASACCIO (1401–1428/9?)
The Virgin and Child, 1426
Tempera on wood, 134.8 × 73.5 cm
Bought with a contribution from The Art Fund, 1916

Despite his untimely death in his late 20s, Masaccio exerted immense influence on other artists. This panel was once at the centre of a complex altarpiece commissioned by a notary for his family chapel in the church of Santa Maria del Carmine in Pisa. This work exemplifies Masaccio's artistic innovations: the three-dimensionality and monumentality of the throne, conceived as a classical temple; the volume and solidity of the Virgin; the use of light and shadow to model the fully rounded Christ Child; the bold foreshortening of the angels' lutes. The iconography, from the grapes symbolising the Eucharistic wine, to the sarcophagus-like base of the throne, is imbued with allusions to the Passion.

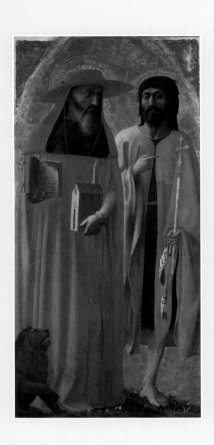

9 **MASACCIO (1401 – 1428/9?) and MASOLINO (about 1383 – after 1436)**
Saints Jerome and John the Baptist, about 1428 – 9
Egg tempera on poplar, 125 × 58.9 cm
Bought with a contribution from The Art Fund, 1950

This picture and *Pope Gregory the Great (?) and Saint Matthias,* also in the National Gallery, were originally the front and back of a single panel that was sawn in two. The panel was the left-hand compartment of a double-sided triptych in the church of Santa Maria Maggiore in Rome. In the mid-1420s Masaccio had collaborated with Masolino, a talented and successful painter in his own right, on the celebrated fresco cycle for the Brancacci Chapel in Santa Maria del Carmine, Florence; it is possible that the two artists joined forces again for this commission, or that, as many believe, Masolino took over after Masaccio's death in around 1428.

On the left Saint Jerome, wearing his characteristic cardinal's dress, is seen holding an open book and a miniature church. The book alludes to the saint's translation of the Bible into Latin; the church presumably refers to Santa Maria Maggiore, Saint Jerome's alleged burial site. At his feet is the lion from whose paw he removed a thorn. The unusual column-shaped cross held by the Baptist is a punning reference to the powerful Roman Colonna family, a member of which, Pope Martin V, may have commissioned the altarpiece.

10 **Fra ANGELICO (active 1417, died 1455)**
Christ Glorified in the Court of Heaven, about 1423 – 4
Tempera on wood, 31.7 × 73 cm
Bought, 1860

Emerging from a vortex of golden rays, Christ appears holding the banner of the Resurrection in one hand and blessing with the other. Around him, in a blaze of colour, a myriad of angels pray, sing and play instruments, their tiny figures differentiated by a multitude of poses and expressions.

This, together with four other panels in the National Gallery, formed the predella of the altarpiece that Fra Angelico made for his own friary, the church of San Domenico at Fiesole, near Florence. The other panels feature the most comprehensive portrayal of saints in the National Gallery: apostles, martyrs, confessors, friars, bishops, prophets and, at the sides, beatified Dominicans. The main tier of the altarpiece, which is still *in situ,* shows the Virgin and Child flanked by saints. While it is probable that in executing this work Fra Angelico employed assistants, the design is most certainly his.

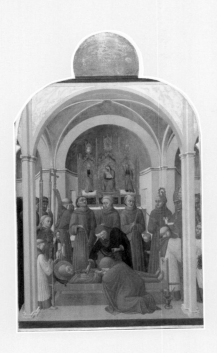

11 SASSETTA (active by 1427, died 1450)
The Funeral of Saint Francis and Verification of the Stigmata, 1437–44
Tempera on wood, 88.4 × 53.5 cm
Bought with contributions from The Art Fund, Benjamin Guinness and Lord
Bearsted, 1934

This is a fragment of a major commission: a double-sided polyptych made by the leading Sienese painter Sassetta for the high altar of the Franciscan church at Borgo San Sepolcro (now Sansepolcro), near Arezzo. On the front of the altarpiece were the Virgin and Child with four standing saints, while the back showed the central figure of Saint Francis in Glory surrounded by eight scenes from his life, seven of which are now in the National Gallery.

Sassetta was a consummate narrator. His depiction of the solemn event captures each figure's reaction to the moment: the bishop reading the service; the little boy, between two friars, peering in; Iacopa, a female follower of Saint Francis, on her knees and weeping in despair; a friar turning away to hide his tears. In the centre the doubting knight Jeronimo reaches down to probe the wound in the saint's breast. The convincingly rendered vaulted chapel shows a triptych, a brilliant visual document of how paintings functioned at this time.

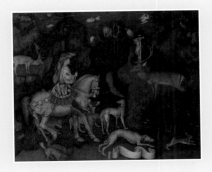

12 PISANELLO (about 1394?–1455)
The Vision of Saint Eustace, about 1438–42
Tempera on wood, 54.8 × 65.5 cm
Bought, 1895

The medallist and painter Pisanello was in high demand in the princely courts of fifteenth-century Italy. His appeal was based on his highly sophisticated style, often characterised by the treatment of religious themes as chivalric tales. Here, Saint Eustace, the second-century Roman soldier who converted to Christianity, is portrayed as a fashionable Renaissance prince. According to *The Golden Legend*, the thirteenth-century compendium of saints' lives by Jacobus de Voragine, Eustace turned to the Christian faith when, while out hunting in the forest, he had a vision of a stag with a Crucifix between its antlers. Pisanello is clearly more interested in the naturalistic representation of animals and birds (of which several preparatory drawings by him still survive) than in their relationship to space. It would appear that the composition originally extended further upwards to include a stretch of sky. The reason why the scroll in the foreground was left blank is unclear, but it has been suggested that it was meant to assert the supremacy of painting over the written word.

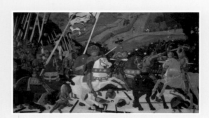

13 Paolo UCCELLO (about 1397–1475)
The Battle of San Romano, probably about 1438–40
Tempera with walnut oil and linseed oil on wood, 182 x 320 cm
Bought, 1857

On 1 June 1432 the Florentines defeated the Sienese, allies of the city of Lucca, in a three-year war for access to the port of Pisa. Uccello depicted the event in three large panels now in London, Paris and Florence. It was long thought that these were commissioned by the Medici, in whose palace they were hanging in 1492, but recent research revealed that Lorenzo the Magnificent took these paintings from the house of the original owners. He had the original arches removed and corners added, thus turning them into rectangular 'gallery pictures'.

The panel's scale and setting – a lush garden with roses, oranges and pomegranates – recalls decorative tapestries. The silver leaf used to decorate parts of the panel has since tarnished, it would have looked quite splendid. In the centre Niccolò da Tolentino, a mercenary who commanded the Florentine forces, triumphantly leads his soldiers on a white charger: his emblem, King Solomon's knot – a symbol of eternity – features on a banner. Uccello applies the mathematical principle of single-point perspective, his alleged obsession, to create a sense of depth. The lines of the broken lances, pieces of armour and dramatically foreshortened dead soldier all converge in a single vanishing point in the centre of the panel.

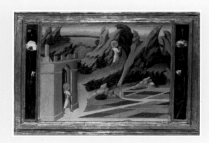

14 GIOVANNI di Paolo (active by 1417, died 1482)
Saint John the Baptist retiring to the Desert, 1454
Tempera on wood, 30.5 x 49 cm
Bought with a contribution from The Art Fund, 1944

In this panel, part of a predella depicting scenes from the life of the Baptist, the artist opts for an old-fashioned device of showing two episodes in one picture: the saint emerging from a city gate and his journey in the wilderness. The style is strikingly archaic: the figure of the Baptist is out of scale with his surroundings; the landscape is dotted with spiky mountains, tiny trees and handkerchief patches of field. Yet the naturalistic roses in the borders suggest that his conservative style was a deliberate choice rather than a lack of skill.

The predella originally consisted of five scenes, four of which are in the National Gallery and one missing. It is generally agreed that Giovanni's set of panels formed the base for his *Virgin and Child with Saints,* now in the Metropolitan Museum of Art, New York.

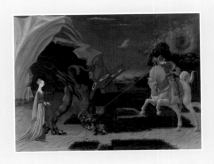

15 Paolo UCCELLO (about 1397–1475)
Saint George and the Dragon, about 1470
Oil on canvas, 55.6 × 74.2 cm
Bought with a special grant and other contributions, 1959

This work, one of the earliest paintings on canvas in the National Gallery, has a troubled history. In 1939 it was confiscated by Nazi troops from the aristocratic Lanckoroński family in Vienna and kept for the planned Hitler Museum in Linz. After the war the painting was returned to the family, who kept it at Hohenems Castle before placing it in a bank. Not long afterwards, the castle and its collection were destroyed in a fire.

The scene shows a well-known story from the life of Saint George, as told in *The Golden Legend* by Jacobus de Voragine. In order to appease a voracious dragon, the inhabitants of Silena, in Libya, would feed him human beings, selecting the victims by drawing lots. When the terrible fate fell on a princess, Saint George saved her by piercing the dragon with his lance; he then instructed the princess to use her girdle as a leash. Uccello compressed the two moments of the narrative into a single scene. To modern viewers, elements such as the grotesque dragon possess a cartoon-like charm.

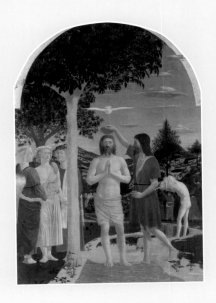

16 PIERO della Francesca (about 1415/20–1492)
The Baptism of Christ, 1450s
Tempera on wood, 167 × 116 cm
Bought, 1861

A successful and admired artist in his own lifetime, Piero was rediscovered as a great master in the mid-nineteenth century and became highly esteemed during the twentieth century. He was a mathematician as well as a painter and published books on geometry and perspective. Already in this early work, painted for the Camaldolese abbey in his native town of Borgo San Sepolcro, Piero shows his preoccupation with compositional balance: the figure of Christ is placed at the very centre of the picture, on an axis running from the top of the arch, through the dove of the Holy Spirit and the baptismal bowl, down to the Redeemer's joined hands and right foot. At Christ's feet the clear water of the river Jordan reflects the hills, trees and draperies of the Pharisees, emphasising the heavenly light. A cool luminosity envelops the scene, imbuing it with a sense of stillness and silence.

17　PIERO della Francesca (about 1415/20–1492)
The Nativity, 1470–5
Oil on wood, 124.4 x 122.6 cm
Bought, 1874

Though it shares the cool tonality and serenity of *The Baptism,* this late work by Piero is quite different: it has no central figure, with the Child a little to the left, the Virgin slightly to the right, and the stable positioned on a diagonal axis. This unusual arrangement, as well as specific iconographic motifs, seem to derive from Netherlandish treatments of the Nativity. Piero's interest in Northern art is also demonstrated by the shift to oil paint, although his inexpert use of the medium has caused some drying defects such as wide cracks.

Surprisingly for such a meticulous artist, technical examination has revealed that much of *The Nativity* was improvised; *pentimenti* (changes of mind) were found in areas such as the shepherd's raised arm, the position of the Child's legs and the folds of Joseph's cloak. Though the painting may have never been completed, its peculiar appearance is to be attributed also to old over-cleaning. Until the mid-nineteenth century, *The Nativity* remained with Piero's descendants, suggesting that it was either made for the family's private use at home or possibly for a local church.

i

ii

18　Fra Filippo LIPPI (born about 1406, died 1469)
19　*The Annunciation and Seven Saints,* about 1450–3
Tempera on wood, 68 x 152.8 cm each
Presented by Sir Charles Eastlake, 1861 (i) and bought, 1861 (ii)

These two panels come from the Palazzo Medici-Riccardi in Florence. Their subjects and shapes suggest that they were originally set into the interior of a bedchamber, probably as overdoors. Allusions to the Medici dynasty may be seen throughout: the seven saints are name-saints of three generations of Medici males, from John the Baptist (Giovanni) in the centre and Cosmas and Damian (patron saints of physicians, 'medici' in Italian) flanking him, to Francis and Lawrence on the left and Anthony Abbot and Peter Martyr on the right. *The Annunciation* incorporates two of the family's emblems: the peacock feathers of Gabriel's wings and a ring carved into the parapet.

Lippi's paintings must have appealed to the powerful Medici family. They repeatedly employed the artist and they granted him a dispensation to marry a nun. Five works by Filippino Lippi, the child of this union and a masterly painter in his own right, are also in the National Gallery.

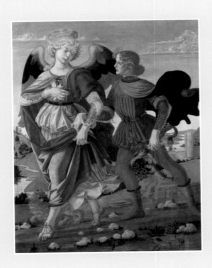

20 **Workshop of Andrea del VERROCCHIO (about 1435–1488)**
Tobias and the Angel, 1470–80
Tempera on wood, 83.6 x 66 cm
Bought, 1867

According to the apocryphal Book of Tobit, the young Tobias was sent by his blind father to collect a debt. During his long journey the disguised Archangel Raphael entreated the youth to extract the liver, heart and gall from a fish to restore his father's sight. The two figures walk arm-in-arm, Tobias carrying the gutted fish and a scroll recording the debt owed to his father, Raphael holding a small jar containing the miraculous ointment. The popularity of Archangel Raphael, venerated both as healer and protector of travellers, made this a common subject in fifteenth-century Florence.

Verrocchio is a key figure in early Renaissance Florence: trained as a goldsmith, famed as a sculptor, he taught many painters in his thriving workshop, but it is not clear what he himself painted. It is certain that this work was entirely carried out by his workshop. It has even been proposed that the young Leonardo da Vinci, one of Verrocchio's apprentices, painted the now-faded dog, the fish and parts of the figure of Tobias.

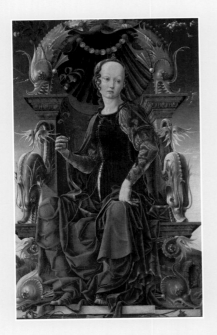

21 **Cosimo TURA (before 1431–1495)**
A Muse (Calliope?), probably 1455–60
Oil with tempera on wood, 116.2 x 71.1 cm
Layard Bequest, 1916

The court painter Tura was one of the most original Italian artists of his time. It is believed that he painted this picture as part of a cycle of Muses (ancient Greek goddesses of learning and the arts) for the *studiolo* of the Este family villa at Belfiore, outside Ferrara. The figure, draped in a magnificent red silk cloth, is seated on a fantastical throne of green and pink marble. It has been suggested that the cherry branch in her right hand is one of the attributes of Calliope, the muse of epic poetry. X-rays have revealed that there is a different composition underneath the present painting, which was probably by another artist. Whereas it would appear that the first version was painted in egg tempera, the current one is in oils. Tura fully grasped the Netherlandish oil technique: he built up successive layers of glazes of varying thickness and used different types of oil for lighter and darker tones. Tura's familiarity with Netherlandish painting may in part be explained by the presence in Ferrara of works by Rogier van der Weyden owned by Leonello d'Este.

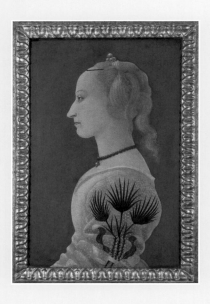

22 Alesso BALDOVINETTI (about 1426–1499)
Portrait of a Lady, about 1465
Tempera and oil on wood, 62.9 x 40.6 cm
Bought, 1866

The fifteenth century saw the rise in popularity of a new painting genre: the individual portrait. Artists depicted individuals to preserve their memory, to celebrate their achievements or, as is probable in this case, to mark a young woman's betrothal or marriage. Here, both the pose and appearance of the sitter reflect the conventions of early Renaissance Italy: the head in profile, with its associations with Roman coins, conveyed the idea of virtue, while the golden blonde hair, pale skin and high forehead conformed to the contemporary ideal of female beauty. The white pearls set in the maiden's hair-band and her necklace symbolise chastity and purity. The sitter has not been conclusively identified, but the motif of three palm leaves on her sleeve is likely to be the heraldic emblem of her family or that of her husband. Baldovinetti modulates the two-dimensionality of the profile view by introducing delicate shadows on the woman's features with a mixture of oil and egg tempera. Unlike so many pictures of the period, this portrait is in its original frame.

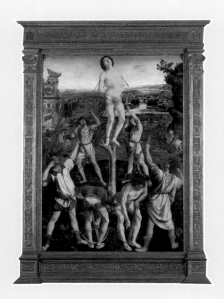

23 Antonio del POLLAIUOLO (about 1432–1498)
and Piero del POLLAIUOLO (about 1441– before 1496)
The Martyrdom of Saint Sebastian, completed 1475
Oil on wood, 291.5 x 202.6 cm
Bought, 1857

In 1474 Antonio Pucci, a wealthy Florentine merchant, paid Antonio and Piero del Pollaiuolo a large sum to make an altarpiece for his family oratory in the church of Santissima Annunziata. Like their rival Andrea del Verrocchio, the Pollaiuolo brothers were goldsmiths, sculptors and painters. Antonio's statuettes, drawings and paintings offered compelling representations of the male body in motion, a theme inspired by his fascination with the Antique. Here his contribution is evident in the bodies of the contorted muscular archers. Like the cavalrymen in the middle distance, the executioners are mirror images of one another. The relatively two-dimensional figure of Saint Sebastian – allegedly a portrait of a known patrician youth – is likely to have been painted by Piero. The effect of aerial perspective in the extraordinarily deep and detailed landscape – a depiction of the Arno valley outside Florence – is achieved with the technique of painting in oils, whereby a sense of gradual recession is conveyed through successively paler layers of oil paint.

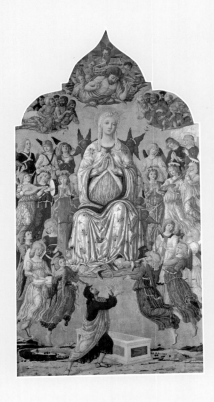

24 MATTEO di Giovanni (active 1452, died 1495)
The Assumption of the Virgin, probably 1474
Tempera on wood, 331.5 × 174 cm
Bought, 1884

Encircled by rows of graceful angels, the Virgin rises up towards Heaven. Inscribed on her halo are the words 'Rejoice, Queen of Heaven'. Above her, a daringly fore-shortened Christ, accompanied by prophets and patriarchs, welcomes his mother. Below her, standing by her empty tomb, Doubting Thomas stretches up to catch Mary's girdle. Saint Thomas' theatricality and energy is reminiscent of Antonio del Pollaiuolo's archers in *The Martyrdom of Saint Sebastian*.

This majestic image was once at the centre of a large polyptych in the church of Sant'Agostino in Asciano, near Siena. In 2007 the principal surviving fragments (which are scattered through Europe and the USA) were reassembled in a convincing reconstruction. By decorating one of its two main churches with this great altarpiece the Augustinians of Asciano were marking Assumption Day, an important date in the liturgical calendar, as well as expressing allegiance to Siena, 'city of the Virgin'.

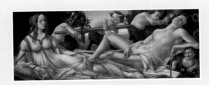

25 Sandro BOTTICELLI (about 1445–1510)
Venus and Mars, about 1485
Tempera and oil on wood, 69.2 × 173.4 cm
Bought, 1874

From the mid-fifteenth century an ever-increasing number of paintings inspired by classical history and literature were made for the sumptuous dwellings of the Florentine élite. This famous picture epitomises this phenomenon: it was probably made on the occasion of a wedding to be displayed above a chest or bed-head in a nuptial bedchamber. It is thought to represent Venus, goddess of love and beauty, calmly contemplating the sleeping Mars, god of war. The child satyrs playing with Mars' armour and spear create a comic effect: one is wearing a helmet (Mars' attribute), another blasts a conch into the god's ear. The wasps (*vespe*) buzzing at the top right may be a punning reference to the Vespucci family for whom Botticelli is known to have worked and among whose members was the famously lovely Simonetta, beloved by Giuliano de'Medici. The contrast between the exposed, exhausted Mars and the clothed and controlled Venus lends itself to different interpretations, one perhaps alluding to the two sexes' contrary responses to lovemaking, the other, more profound, to the victory of love over war.

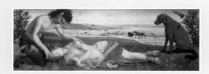

26 PIERO di Cosimo (1462–1522)
A Satyr mourning over a Nymph, about 1495
Oil on wood, 65.4 x 184.2 cm
Bought, 1862

In this moving picture, a satyr tenderly touches the half-naked body of a nymph. The wounds on her body betray a violent death. Though the subject has not been conclusively identified, the scene has been associated with the tragic mythological tale of Cephalus and his wife Procris, told by Ovid in his *Metamorphoses* (VII, 795 –865). Believing rumours of her husband's infidelity, Procris spied on him while he was resting after the hunt. Mistaking a rustling noise made by his wife for a wild animal, Cephalus threw a spear and mortally wounded her.

Like Sandro Botticelli's *Venus and Mars*, this painting would probably have decorated a bedchamber in a Florentine palace. If the link with Procris' story is correct, it may have been commissioned by a bridegroom to warn his young bride of the dangers of unfounded jealousy. Piero's love of nature and animals, chronicled by Giorgio Vasari, is seen in the accurate depiction of dogs, pelicans and plants.

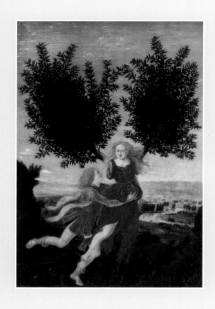

27 Antonio del POLLAIUOLO (about 1432–1498)
Apollo and Daphne, probably 1470–80
Oil on wood, 29.5 x 20 cm
Wynn Ellis Bequest, 1876

In Ovid's *Metamorphoses* (I, 525–655), the vengeful Cupid impelled the god Apollo to pursue the nymph Daphne. She prayed to her father (the river god Peneus) for rescue and was transformed into a laurel tree as Apollo touched her. Pollaiuolo's depiction of this pagan tale evokes the idea of unattainable courtly love, with Apollo dressed in an elegant contemporary costume and Daphne portrayed as the ideal beauty of Petrarch's poems. The pair are intertwined in a balletic pose and lifted in a graceful motion. In the background the river Arno winds down towards a misty horizon.

In the past, experts suggested that *Apollo and Daphne* was originally set into a *cassone* (marriage chest), but it is in unusually good condition – furniture is always vulnerable to scuffing. Rather, the painting's scale and quality seem to indicate that it was made as a precious object for a learned collector, someone who would have appreciated both its erudite references and its technical refinement. It has been suggested that it was painted for Lorenzo de' Medici, whose personal standard included a laurel tree and a nymph.

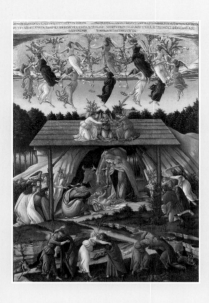

28 Sandro BOTTICELLI (about 1445–1510)
'Mystic Nativity', 1500
Oil on canvas, 108.6 x 74.9 cm
Bought, 1878

This, Botticelli's only signed painting, is known as the *'Mystic Nativity'* because of the rich and complex meanings contained in its imagery. In the golden sphere of heaven, angels dance in a circle; on earth, they guide the shepherds to the newborn Saviour. Dressed in the colours of Faith, Hope and Charity – white, green and red – they hold olive branches as symbols of peace, and carry scrolls. These refer to the Virgin as 'Queen above all' (hence the crowns), announce Christ as 'the Lamb of God' and proclaim 'peace and good will towards men'. At the top of the canvas, a Greek inscription links contemporary events to the Book of Revelation's prophecy, in Chapter 11, of 'the release of the devil'. Botticelli is covertly alluding to the period of political turmoil that afflicted Florence following the death of Lorenzo de' Medici and the execution of Girolamo Savonarola, a reforming Dominican friar who had preached that luxuries – including paintings and books – were sinful. But the artist, who believes in the promise of Christ's return to earth, concludes: 'we shall see him [the devil] buried as in this picture'.

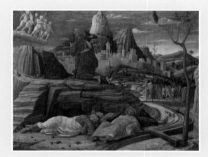

29 Andrea MANTEGNA (about 1430/1–1506)
The Agony in the Garden, about 1460
Tempera on wood, 62.9 x 80 cm
Bought, 1894

According to all four Gospels, after the Last Supper, Christ went with his disciples to the garden of Gethsemane; while the others waited, Jesus withdrew with Peter, John and James to pray. Mantegna's portrayal of the dramatic moment before Christ's arrest is dominated by a harsh and arid landscape, its angular, striated rocks reminding us of the painter's fascination with geology. While the three disciples are sprawled in a deep sleep, five putti appear before Christ holding the instruments of his Passion. Beyond, from the gates of Jerusalem, a gesticulating Judas leads a long column of Roman soldiers coming to arrest Christ. Mantegna, a passionate student of Classical antiquities, paints the holy city as a fantastical cityscape containing examples of Rome's ancient monuments. While the vulture is an ominous sign of death, hope rests in the rabbits and in the egrets in the water, possible allusions to salvation and baptismal purification.

Giovanni Bellini, Mantegna's brother-in-law, was certainly influenced by this work when painting his *Agony in the Garden* (also in the National Gallery).

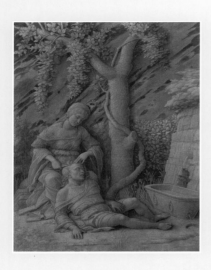

30 **Andrea MANTEGNA (about 1430/1–1506)**
Samson and Delilah, about 1500
Glue size on linen, 47 x 36.8 cm
Bought, 1883

Mantegna's lifelong love affair with the Classical world began in the Paduan workshop of his adoptive father, the painter Francesco Squarcione. The young painter's fascination with Græco-Roman art was fuelled by the example of Donatello, who was working in Padua between 1443 and 1453. This small picture, painted late in the artist's career, is one of the many works that manifests the artist's obsession with Classical sculpture. The *grisaille* (monochrome grey) figures are painted on a veined ground to create the illusion of stone bas-relief on coloured marble. The subject derives from the Old Testament (Judges 16: 4–20). The Israelite hero Samson was betrayed by the beautiful Delilah, his Philistine lover. While he lay asleep in her lap, a man shaved off Samson's hair, the source of his strength. In Mantegna's portrayal it is Delilah who cuts Samson's locks. The heavy clusters of grapes imply that she used wine to drug Samson, while the proverb inscribed in Latin on the tree-trunk leaves no doubt as to the viciousness of her deed: 'A bad woman is three pence worse than the devil.'

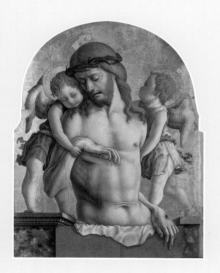

31 **Carlo CRIVELLI (about 1430/5–about 1494)**
The Dead Christ supported by Two Angels, about 1470–5
Tempera on wood, 72.4 x 55.2 cm
Bought, 1859

Although he came from Venice – one of Europe's major artistic centres – Crivelli achieved success painting altarpieces for the churches of small towns in the Italian Marches. This panel was originally at the centre of the upper tier of a polyptych in the church of San Francesco in Montefiore dell'Aso, near Fermo. The ensemble was partially dismembered in the nineteenth century.

Paintings on the theme of the dead Christ supported by angels were often inspired by Donatello's sculptural reliefs. Crivelli painted at least 11 variations, but this particular version stands out for its understated emotion and the beauty of its precise execution. While the subtle shading that shapes Christ's emaciated torso is achieved though fine hatching, his protruding veins, folds of flesh and facial features are strongly marked. The sad, downcast gaze of the angel shows a rare subtlety of expression. The painting retains its original varnish, but part of the profile of the angel on the right, the upper right section of Christ's head and the gilding around it have been reconstructed in a recent restoration.